OKLAHOMA
impressions

Photography by JIM ARGO

FARCOUNTRY
PRESS

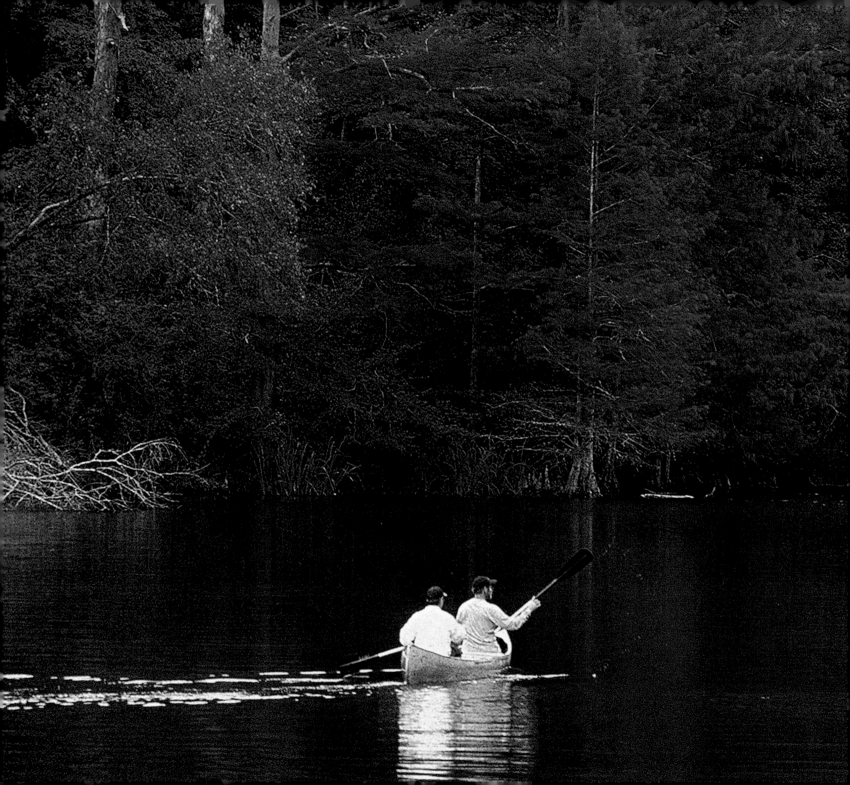

Left: Canoeists paddle down the Mountain Fork River, surrounded by a hardwood forest bright with autumn yellows and reds.

Title page: Once a stop on the California Trail, the 310-acre Red Rock Canyon State Park is now popular with climbers who enjoy rappelling the steep canyon walls.

Front cover: Tall stalks of yucca appear in the foreground of this view of Lake Altus-Lugert from the Horizon Trail in Quartz Mountain Nature Park in southwestern Oklahoma.

Back cover: The sun sets on Broken Bow Lake, situated in Beavers Bend State Park in southeastern Oklahoma.

ISBN 10: 1-56037-384-9
ISBN 13: 978-1-56037-384-1
Photography © 2006 by Jim Argo
© 2006 Farcountry Press

For more information about our books write Farcountry Press, P.O. Box 5630, Helena, MT 59604; call (800) 821-3874; or visit www.farcountrypress.com.

Created, produced, and designed in the United States. Printed in China.

10 09 08 07 06 1 2 3 4 5

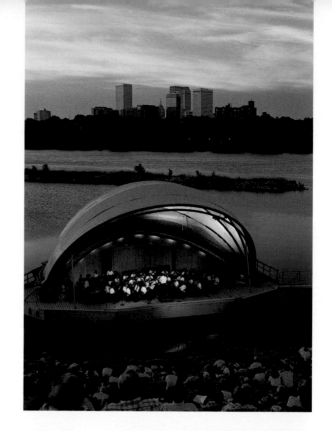

Right: Located in River Parks along the Arkansas River, the Reynolds Amphitheater features numerous outdoor concerts and the Tulsa skyline in the background.

Far right: The clean lines of the Tulsa skyline border the tree-shaded river walk, with more than twenty miles of paved trails.

Below: The sculpture *The End of the Trail,* by sculptor James Earle Fraser, is the signature piece at the atrium entrance of the National Cowboy and Western Heritage Museum.

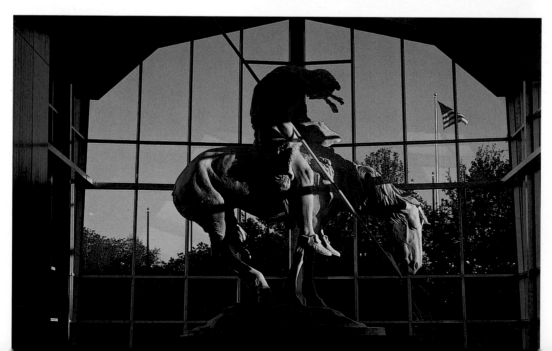

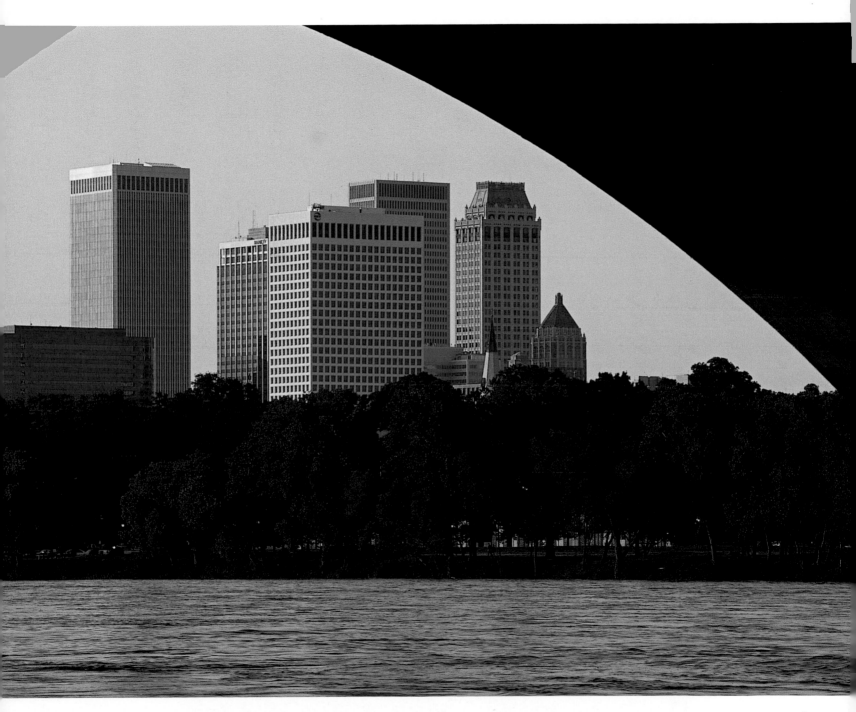

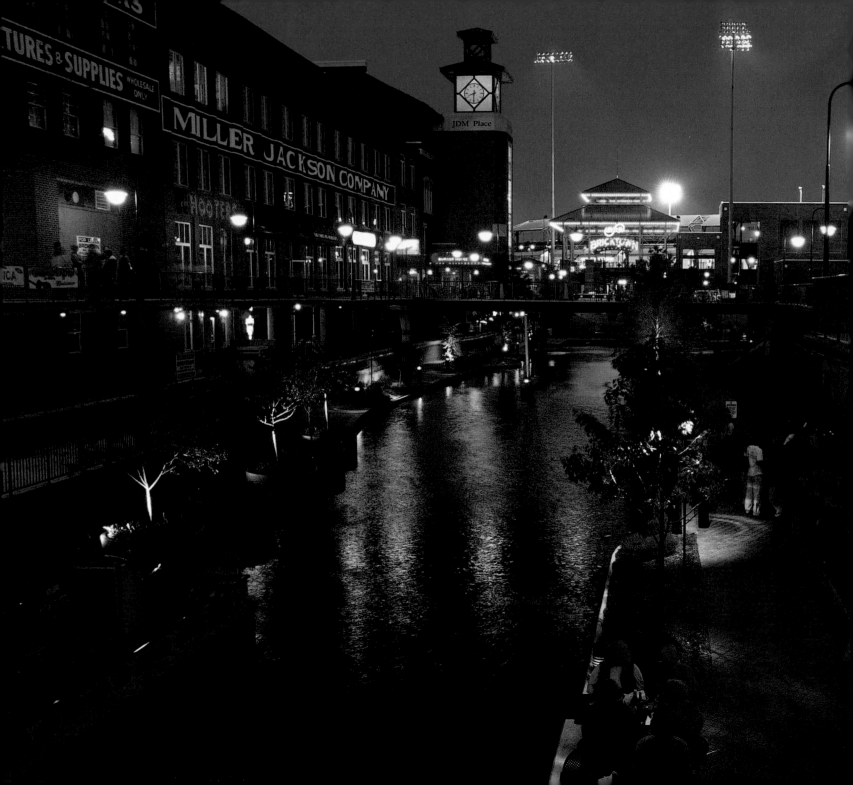

Left: Renamed Bricktown, this area in Oklahoma City was once the crossroads of railroad commerce and a warehouse district. Today, it features a manmade canal with water taxis and is a place to enjoy fine dining, shop for antiques, and watch the AAA farm team of the Texas Rangers.

Below: The Chickasha Festival of Light features a 172-foot Christmas tree and more than three million lights.

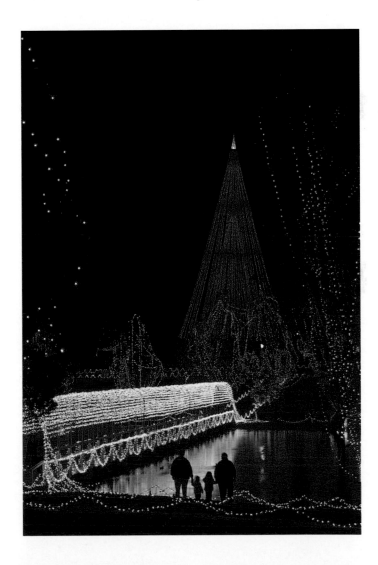

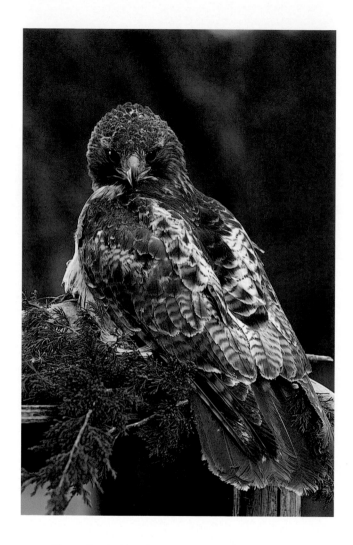

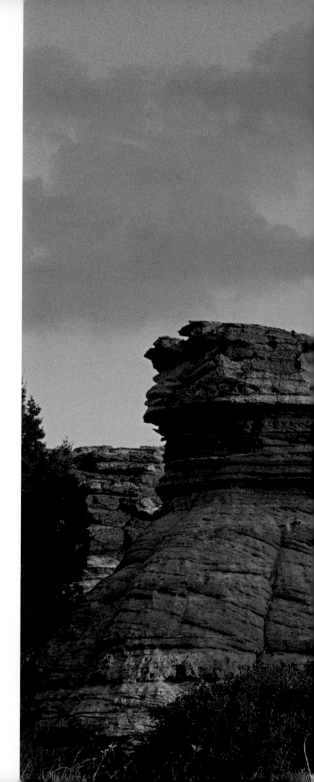

Above: This red-tailed hawk is a resident at WildCare, a facility outside Noble that rehabilitates injured wild animals.

Right: These Dakota sandstone formations in Cimarron County are known as "The Three Sisters" or "The Wedding Party"—a well-known landmark in the Oklahoma Panhandle.

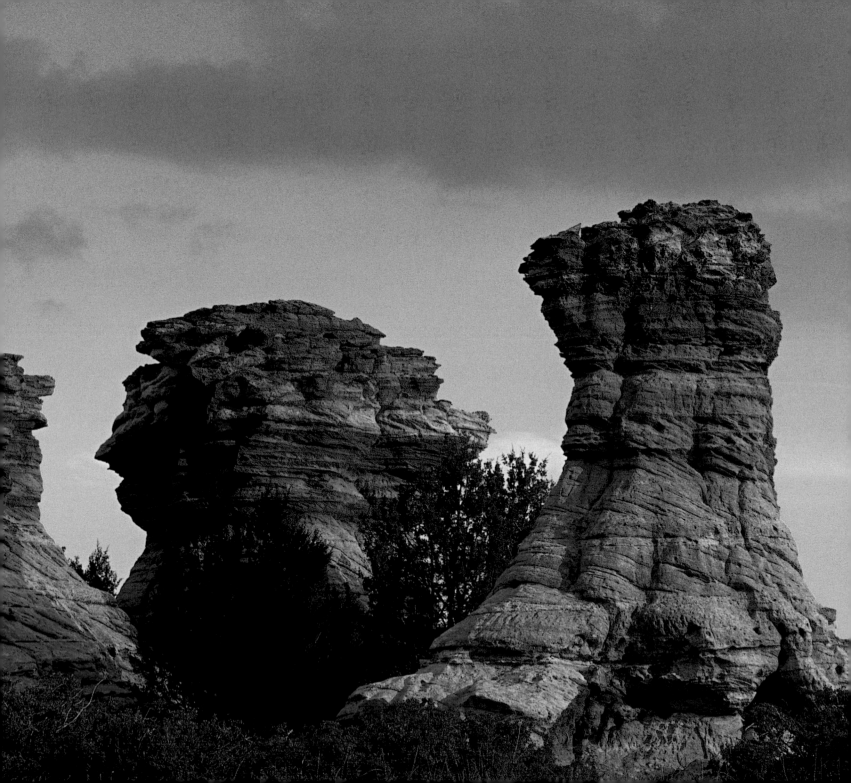

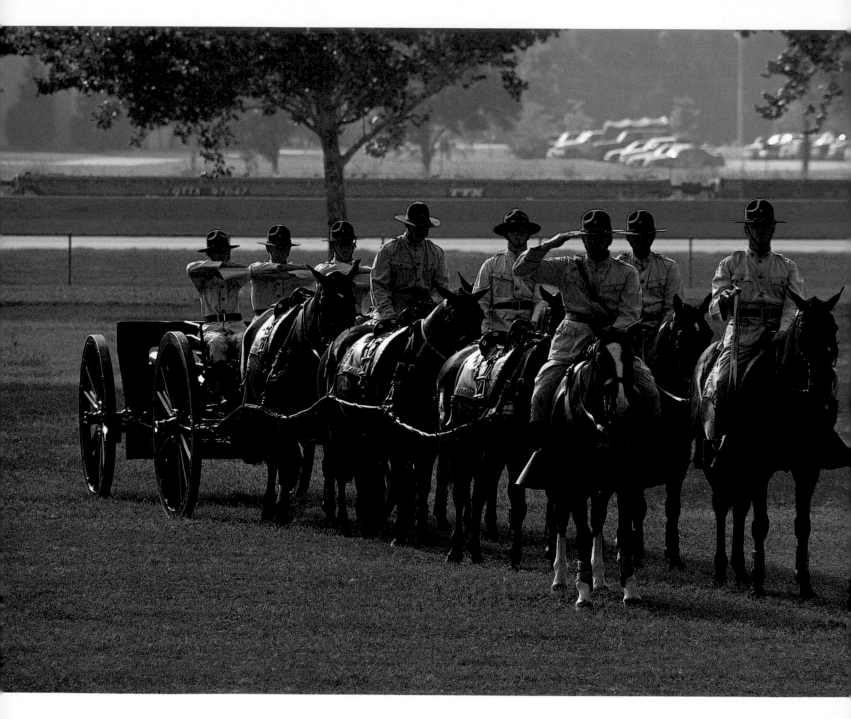

Left: Owned by the Nature Conservancy, the 37,000-acre Tallgrass Prairie Preserve in Osage County features more than 500 species of plants in the prairie ecosystem.

Far left: Half-section D field artillery practices at Fort Sill, which has a U.S. Army field artillery school on its 15,000-acre reservation.

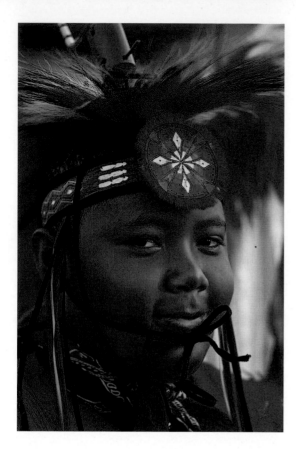

Right: With bells jingling and feathers flying, participants make the Grand Entry at the annual Red Earth Festival in Oklahoma City, which draws tribal members from throughout North America.

Below: Dressed in full regalia, Native Americans parade through downtown Oklahoma City during the Red Earth Festival.

Above: This Plains Indian boy in full ceremonial dress takes part in the American Indian Exposition in Andarko. Held annually in August, the exposition is one of the oldest and largest intertribal gatherings in the United States.

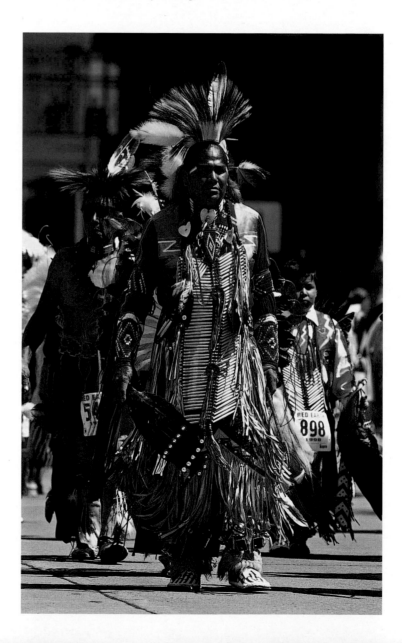

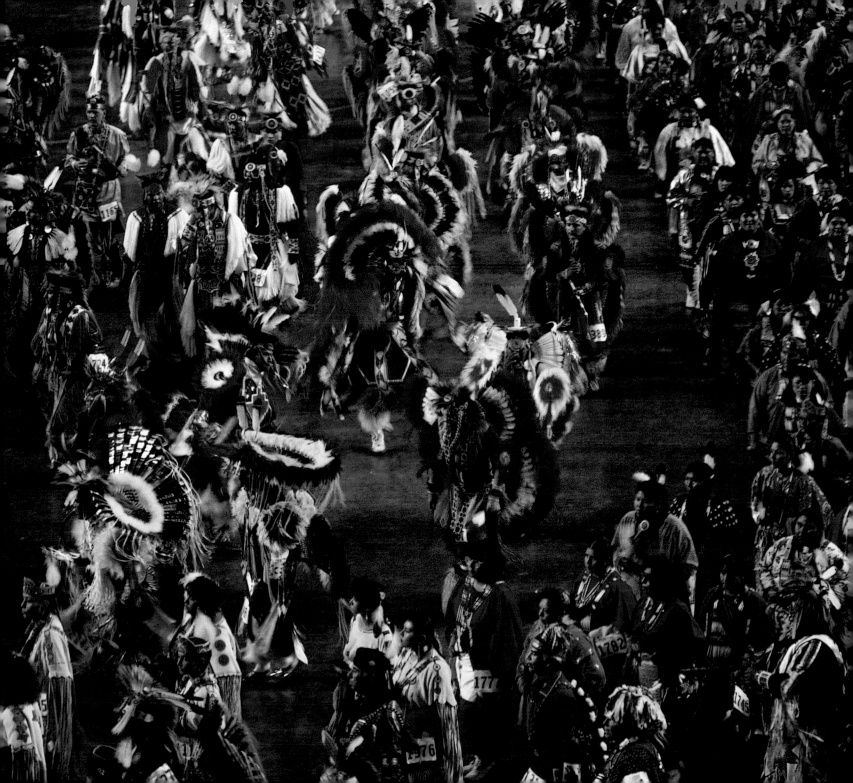

Right: Autumn gilds the tall grasses in the Tallgrass Prairie near Whizbang, once a booming oil community and now a ghost town, in Osage County.

Below: This buffalo stands tall on the mixed-grass prairie of the 59,020-acre Wichita Mountains Wildlife Refuge in southwestern Oklahoma.

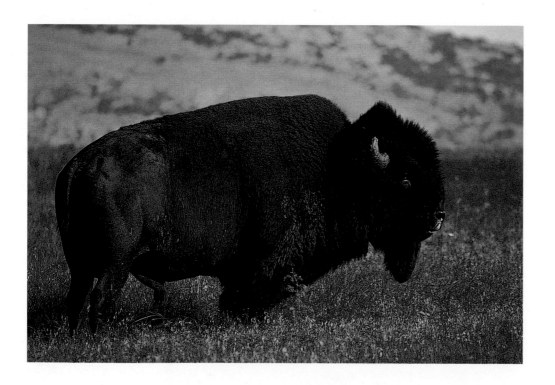

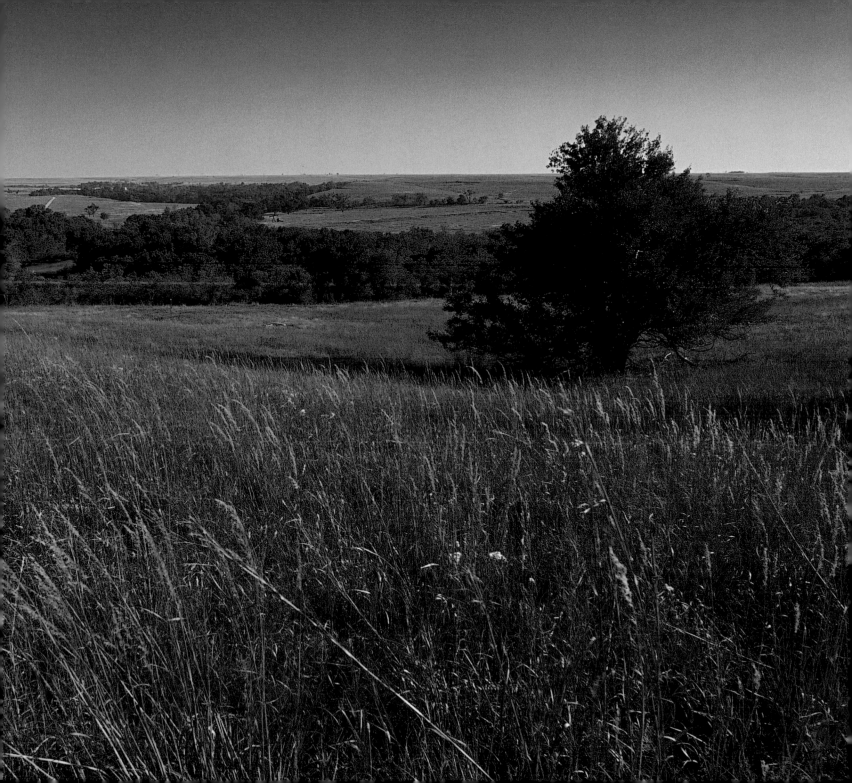

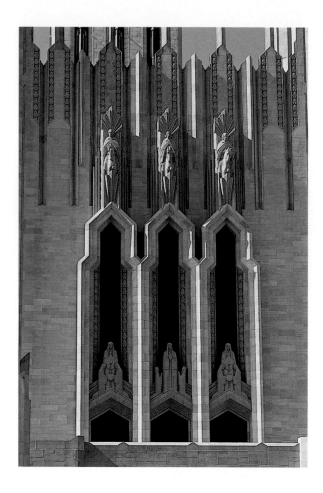

Above: One of the many art deco buildings in Tulsa, the unique Boston Avenue Methodist Church is listed on the National Register of Historic Places.

Right: The original plans for the Oklahoma state capitol, built from 1914 to 1917, called for a dome, but the 155-foot dome topped with a seventeen-foot bronze statue of a Native American—*The Guardian,* by sculptor Kelly Haney—was not added until 2002.

Below: In front of the city hall in the quiet town of Durant is this homage to the world's largest peanut.

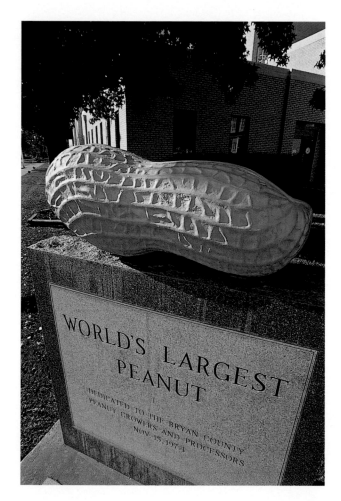

WORLD'S LARGEST PEANUT

DEDICATED TO THE BRYAN COUNTY
PEANUT GROWERS AND PROCESSORS
NOV 13, 1974

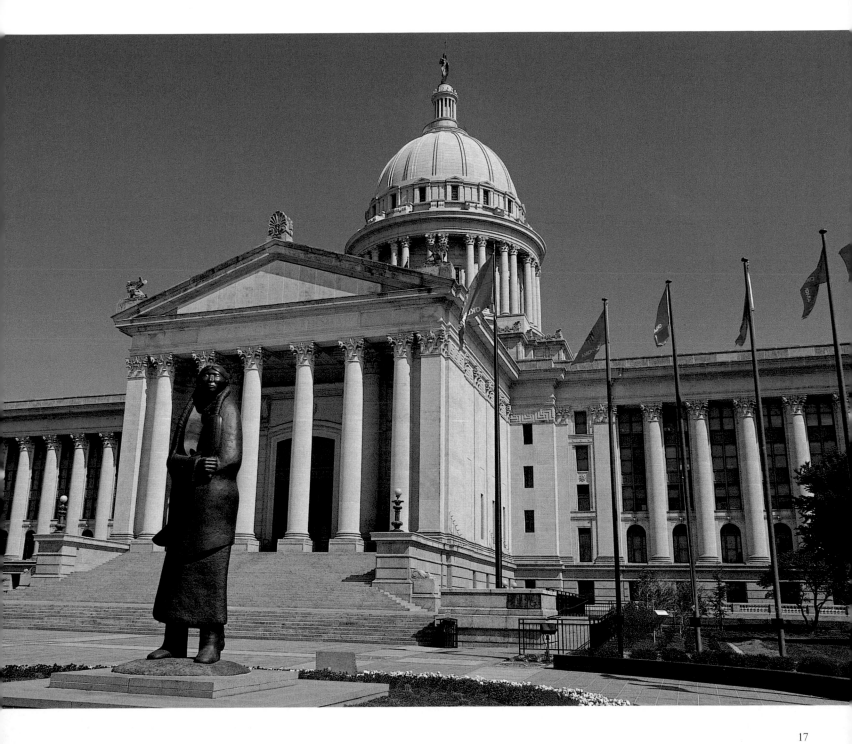

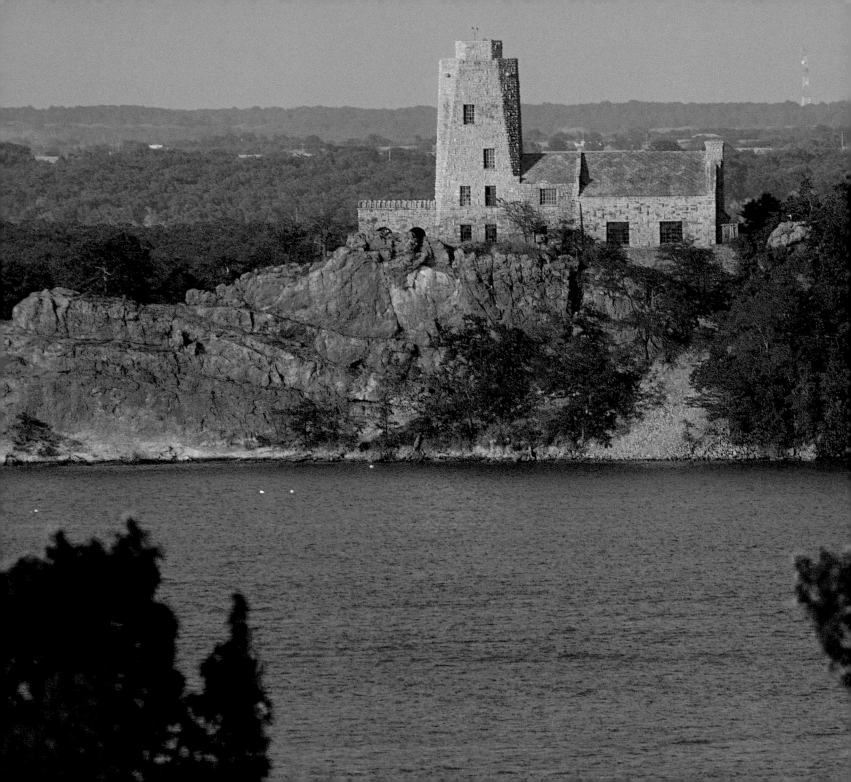

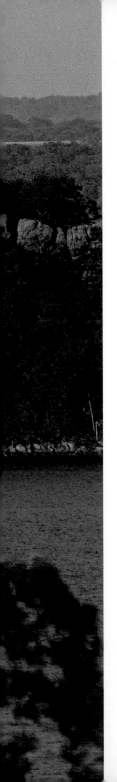

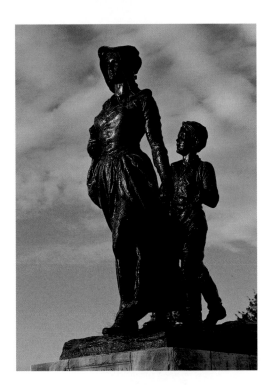

Left: This thirty-foot bronze statue of a pioneer woman and child, sculpted by Englishman Bryant Baker, stands in front of Ponca City's Pioneer Woman Museum, which showcases the history of women in Oklahoma.

Far left: Tucker Tower, now a nature preserve with displays on local wildlife, sits on the southern shore of Lake Murray in the same-named state park that occupies 12,500 acres and is Oklahoma's largest state park.

Below: This bronze is one of forty-six statues designed by Paul Moore that commemorate the historic land rush of April 22, 1889, at the Oklahoma Centennial Land Run Monument.

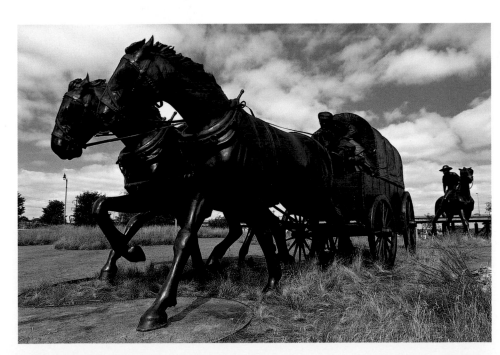

Right: A timeless image in Oklahoma: two cowboys, young and old, perch on the tongue of a covered wagon.

Below: An orange sunset fades into purple on the shores of Lake Hulah. Now a state park, this area in northern Oklahoma was named Wah-Sha-She (meaning "the water people") by Osage Indians.

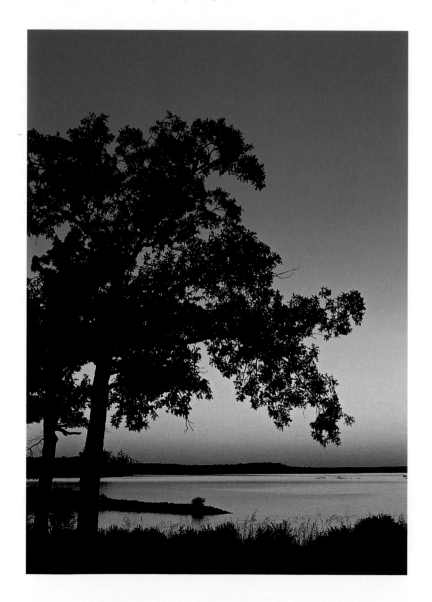

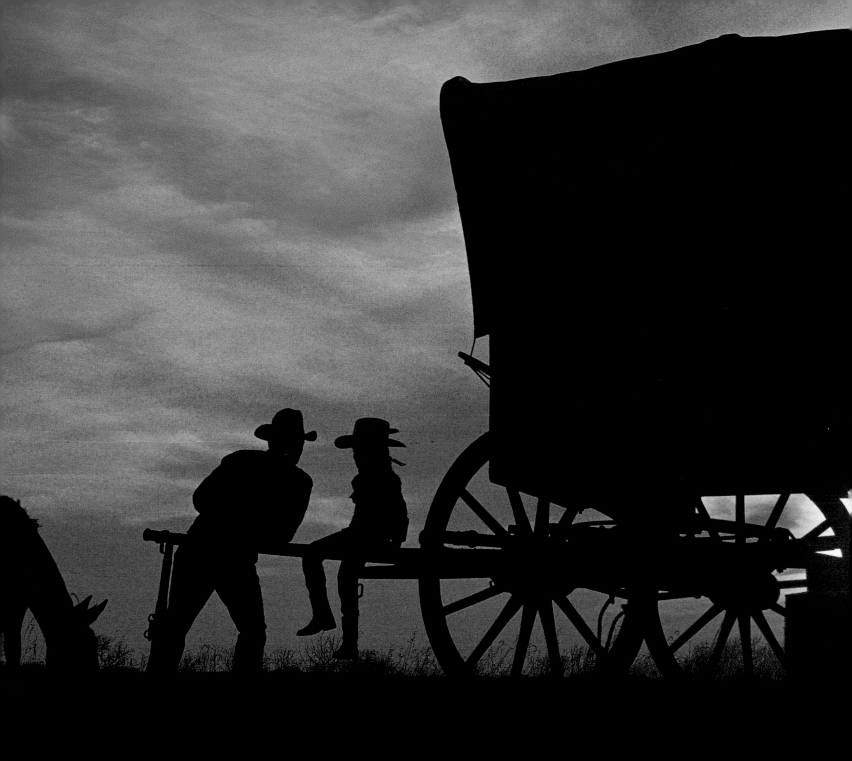

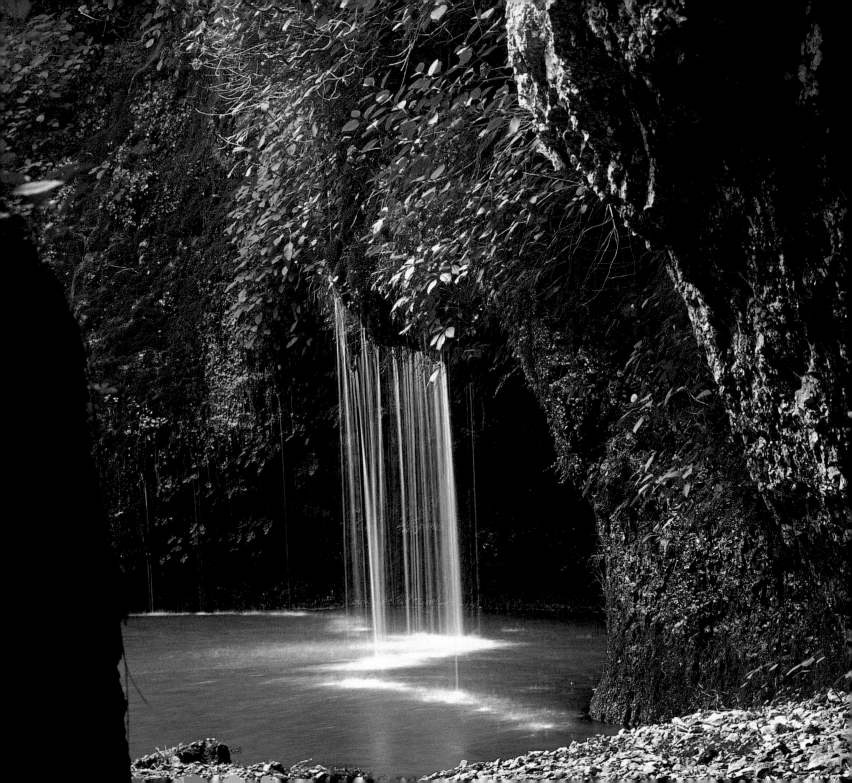

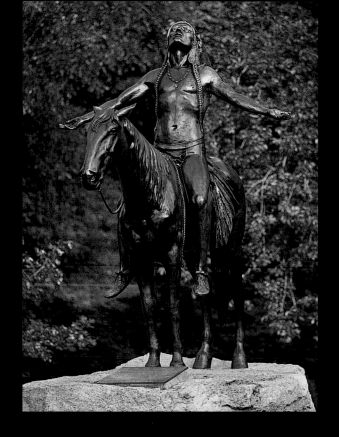

Left: This bronze sculpture entitled *Appeal to the Great Spirit* by Cyrus Dallin is located in Woodward Park, adjacent to the Tulsa Garden Center and Arboretum and one of 140 parks in Tulsa.

Far left: Water cascades into a pool in Natural Falls State Park in northeastern Oklahoma. This was the setting for the 1974 movie *Where the Red Fern Grows.*

Below: The bronze *Sacred Rain Arrow* by Allan Houser is located on the 460-acre grounds of the Gilcrease Museum in Tulsa. It is home of the world's largest collection of western art, with nearly 10,000 paintings, drawings, prints, and sculpture by more than 400 artists.

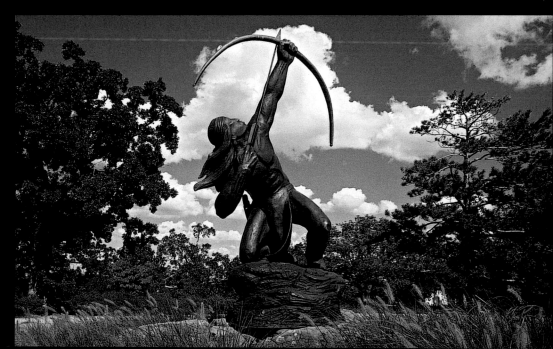

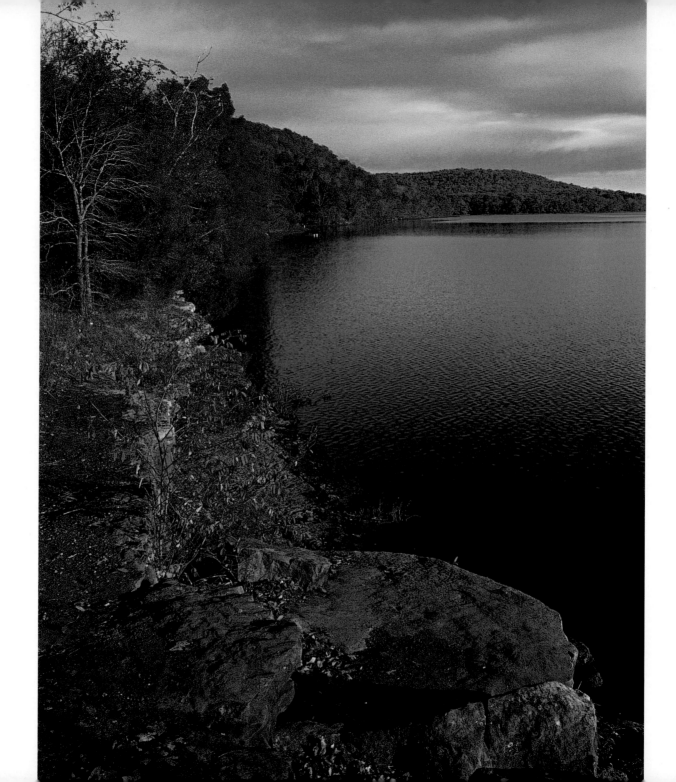

Above: Trees show off their fall color along Lake Carlton in southeastern Oklahoma's 8,246-acre Robbers Cave State Park.

Facing page: Fall foliage lights the shore of 930-acre Greenleaf Lake in the same-named state park in eastern Oklahoma.

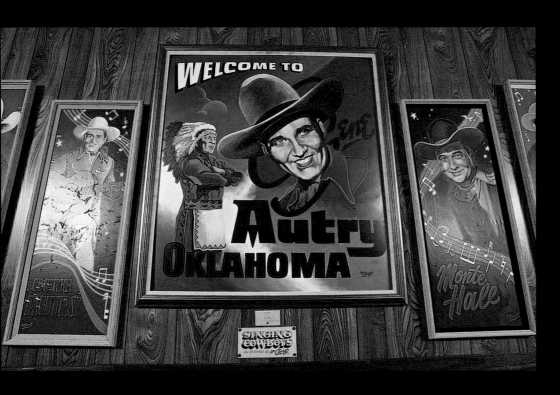

Above: These movie-style posters welcome visitors to Gene Autry, Oklahoma. The town of Berwyn was renamed in 1941 for Gene Autry, a movie and recording star of the 1930s and 1940s.

Right: Who's studying whom? Children or elephants, it's a toss-up here in Hugo, the wintertime home of two traveling circuses.

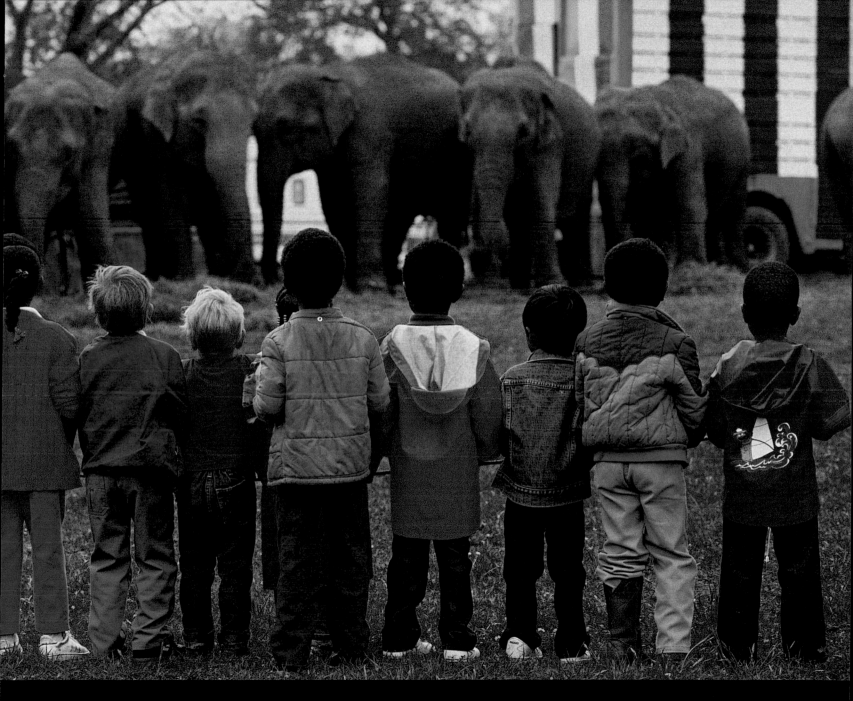

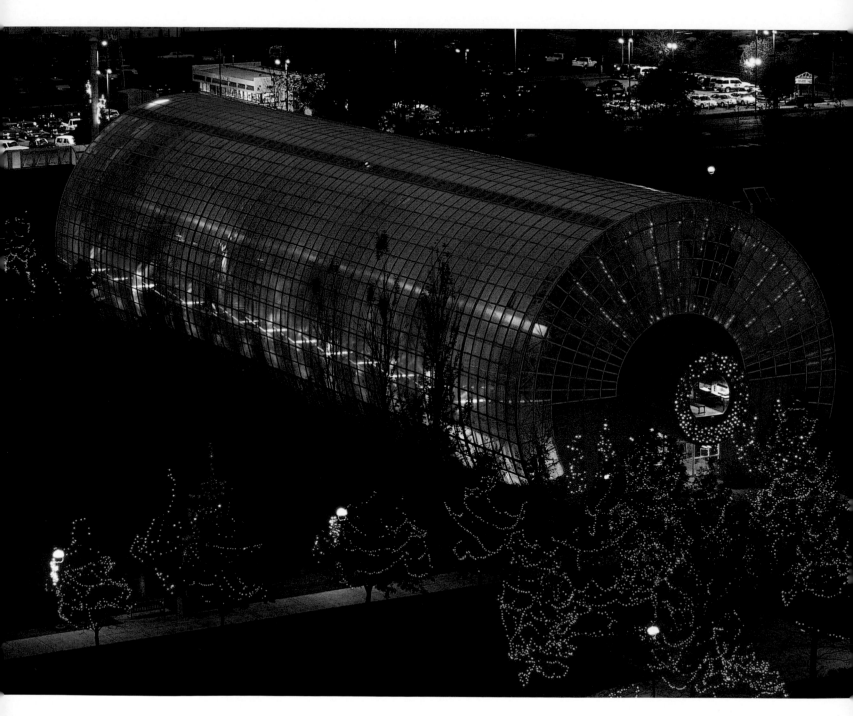

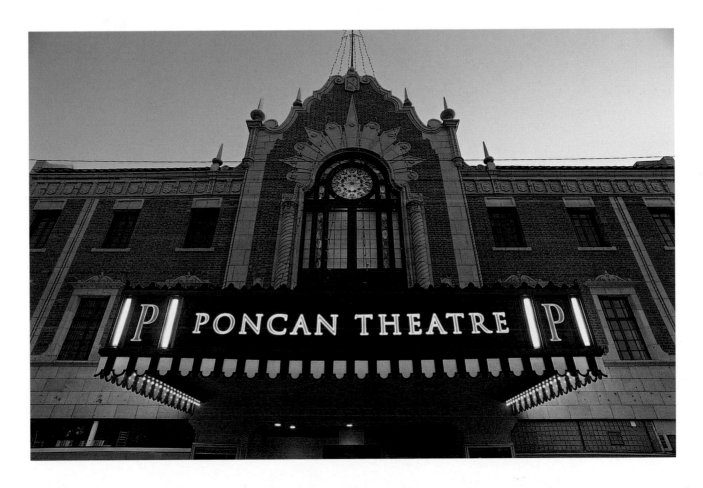

Above: The Poncan Theatre of Ponca City was built in 1927 but closed in 1985. Nine years later, the Spanish colonial revival–style theatre was reopened and is now listed on the National Register of Historic Places.

Left: In downtown Oklahoma City, holiday lights illuminate the Crystal Bridge Tropical Conservatory in the seventeen-acre Myriad Botanical Garden.

Right: Galaxy, the fourteen-ton, forty-five-foot-high sculpture by Alexander Lieberman, brightens Leadership Square in Oklahoma City.

Far right: One of forty-five vintage windmills turns in the breeze at the Shattuck Windmill Museum in northwestern Oklahoma.

Below: Get your kicks at the National Route 66 Museum in Elk City, which features exhibits and recorded reminiscences about the eight-state "mother road" from the 1946 pop song by Bobby Troup made famous by Nat King Cole.

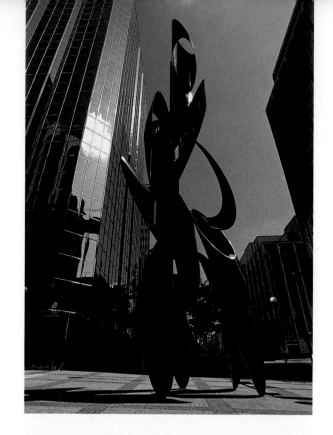

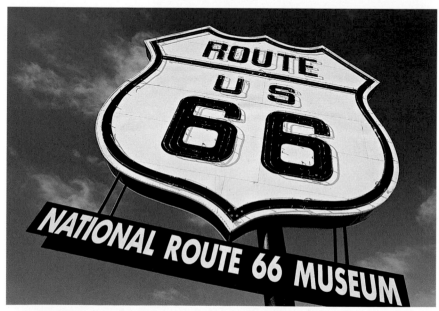

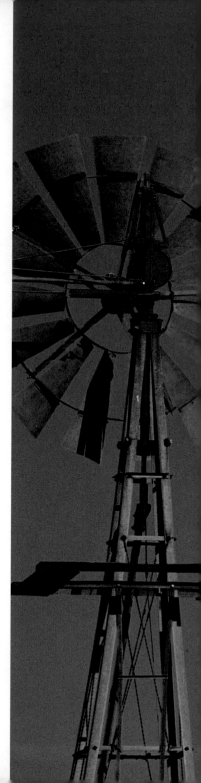

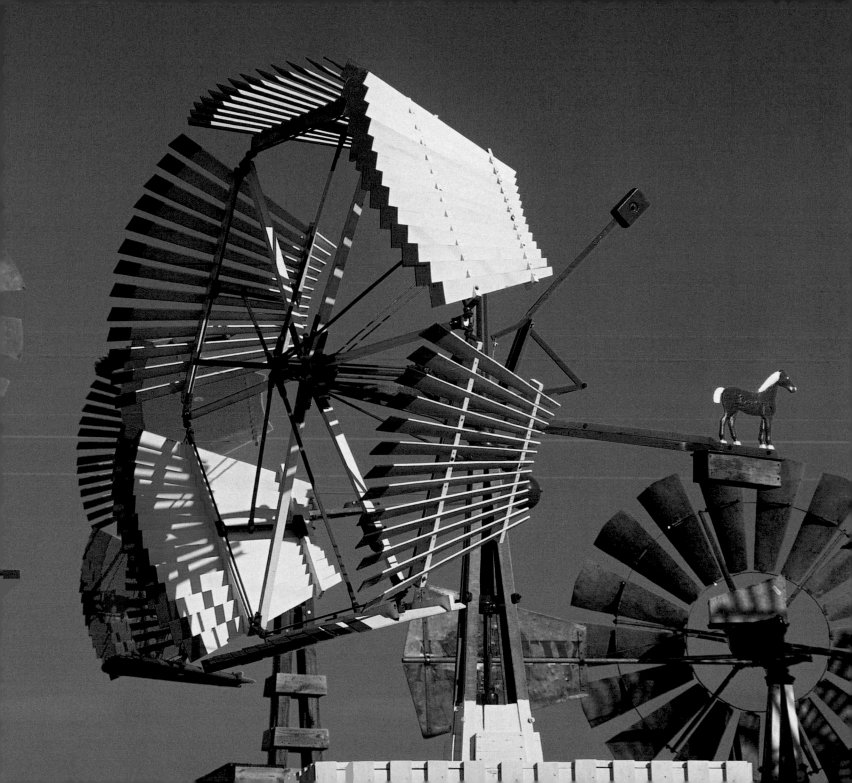

Right: Once surrounded by oil wells, the 1917 Oklahoma state capitol is built of limestone and has black granite steps and a marble floor. The dome was added in 2002.

Far right: The Philbrook Museum of Art, an Italianate villa built on twenty-three acres in 1927 by oilman Waite Phillips, has evolved into Tulsa's art center and features lush gardens of Oklahoma native plants.

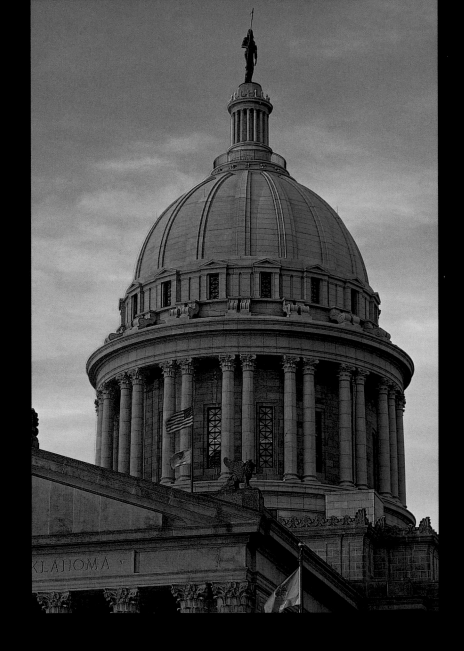

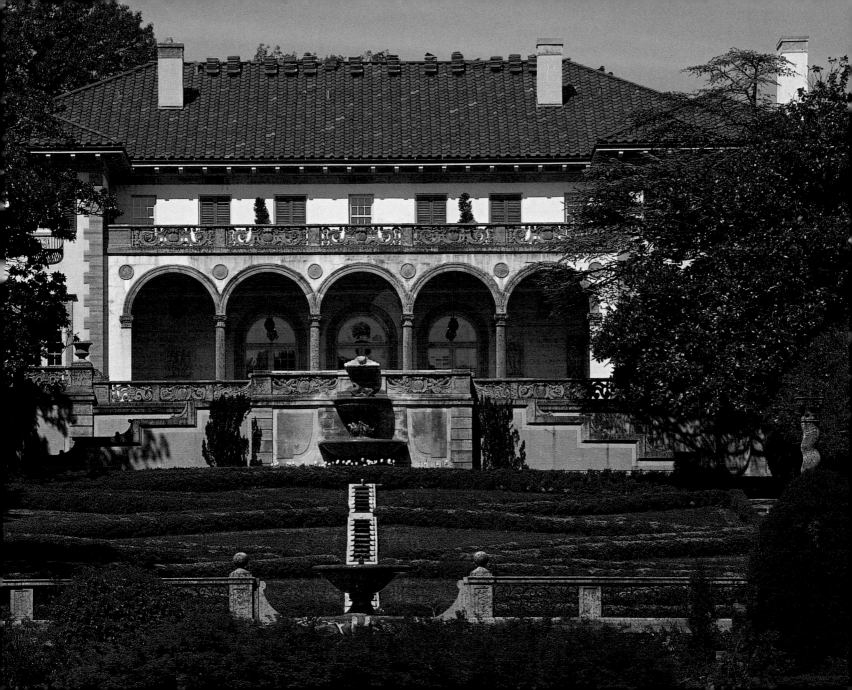

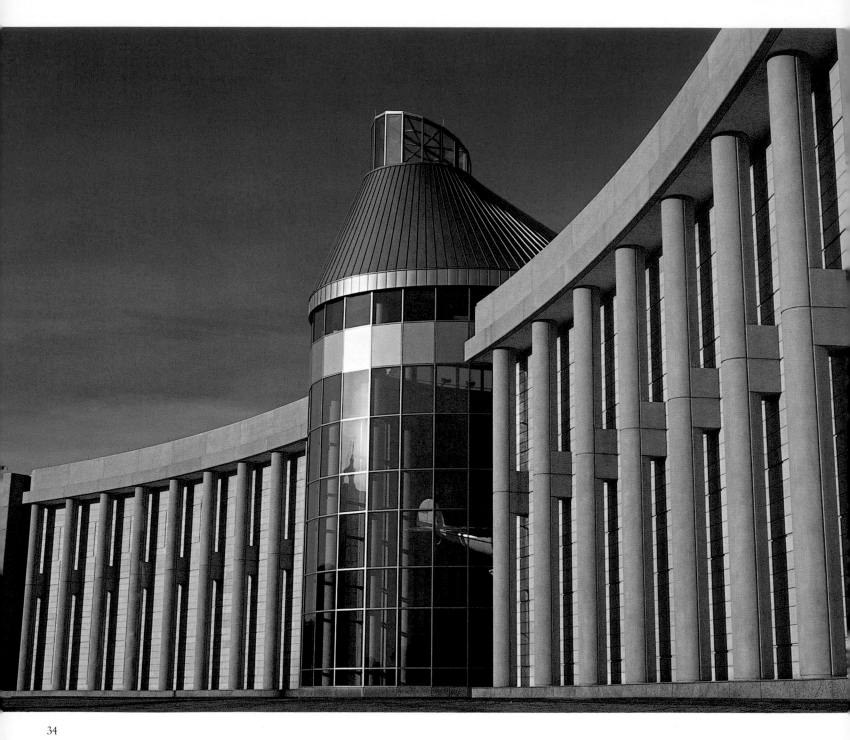

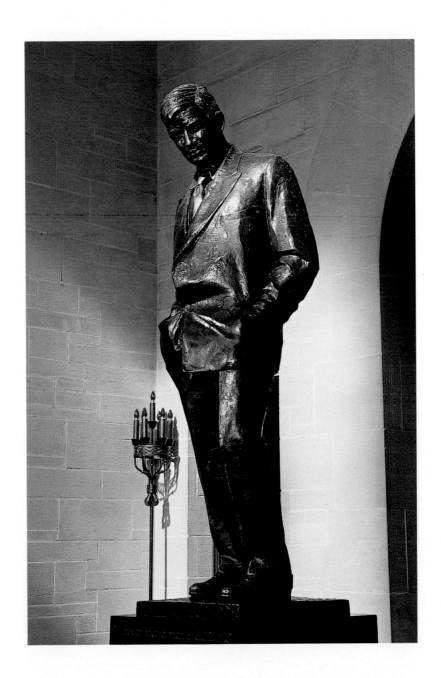

Left: This bronze statue of Will Rogers, the humorist, actor, and journalist who was born in Indian Territory (now Oklahoma) in 1879, is featured at the nine-gallery Will Rogers Memorial Museum in Claremore. The statue is by Jo Davidson.

Far left: The 215,000-square-foot, architecturally stunning Oklahoma History Center is situated on eighteen acres of landscaped grounds and features exhibits on Oklahoma geology, culture, and history.

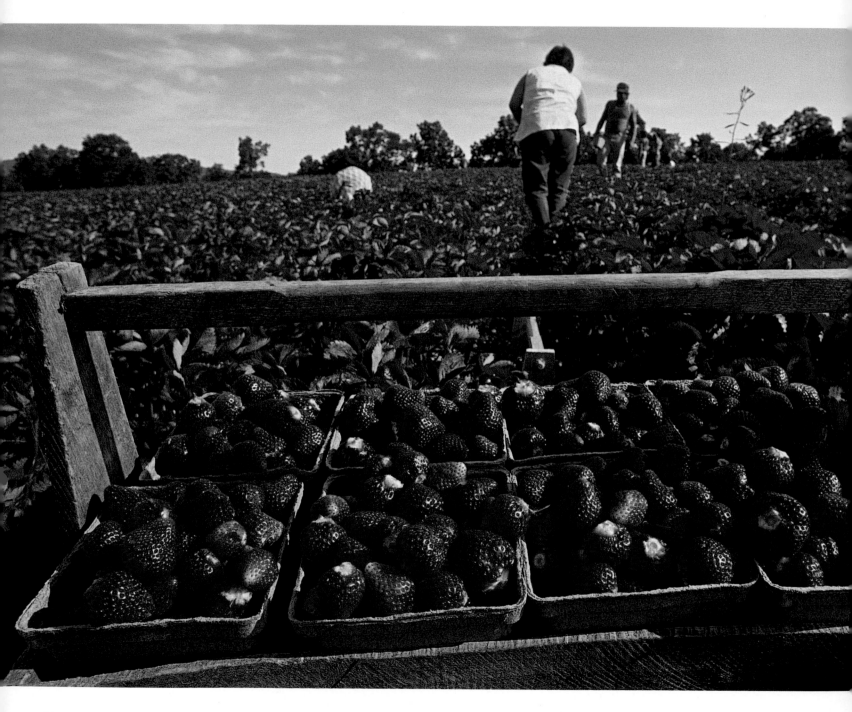

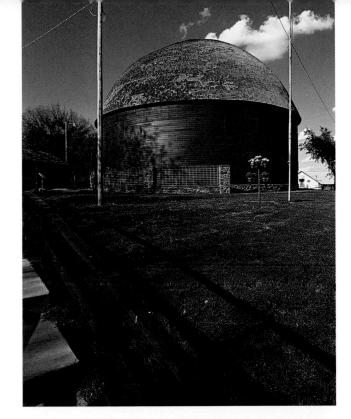

Left: Located on Route 66 in Arcadia, the forty-five-foot-tall Round Barn was built in 1898 by William Harrison Odor and was restored by volunteers after the roof collapsed in 1988.

Far left: Plump, juicy strawberries are celebrated each May at the Strawberry Festival in Stilwell, the town that has dubbed itself "The Strawberry Capital of the World."

Below: This Texas longhorn steer is one of fifty mammals roaming the mixed-grass prairie of the Wichita Mountains Wildlife Refuge in southwestern Oklahoma.

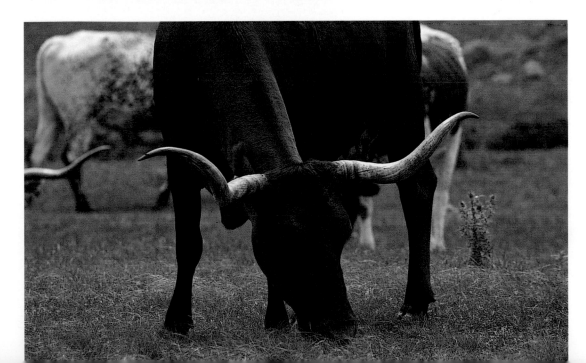

Right: Sand Creek flows over the rock ledges in 1,100-acre Osage Hills State Park, an area that is a gateway to Oklahoma's tallgrass prairie and once featured an Osage Indian settlement.

Below: Two baby raccoons crouch in the grass in Beavers Bend State Park, located at the base of Broken Bow Lake in southeastern Oklahoma.

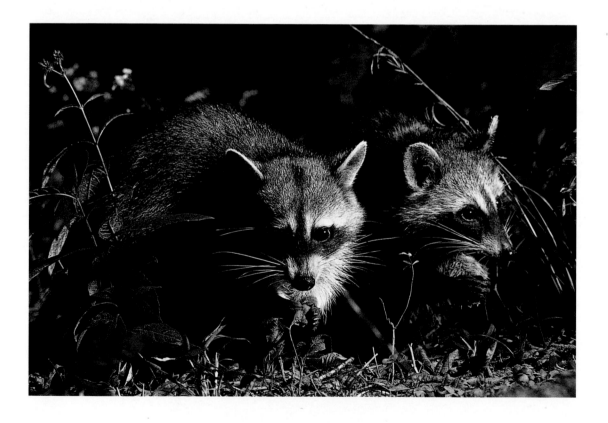

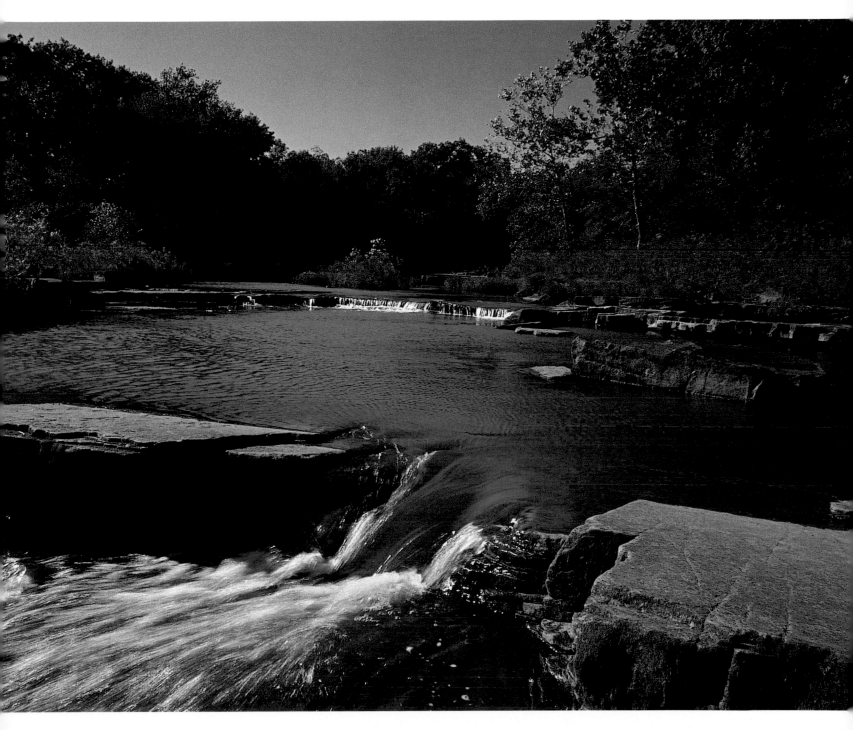

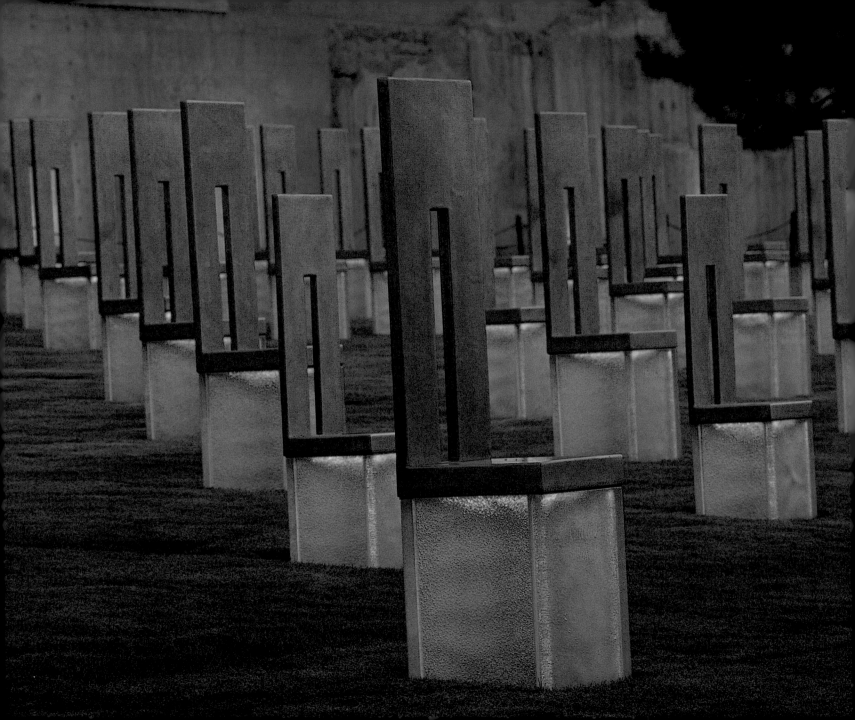

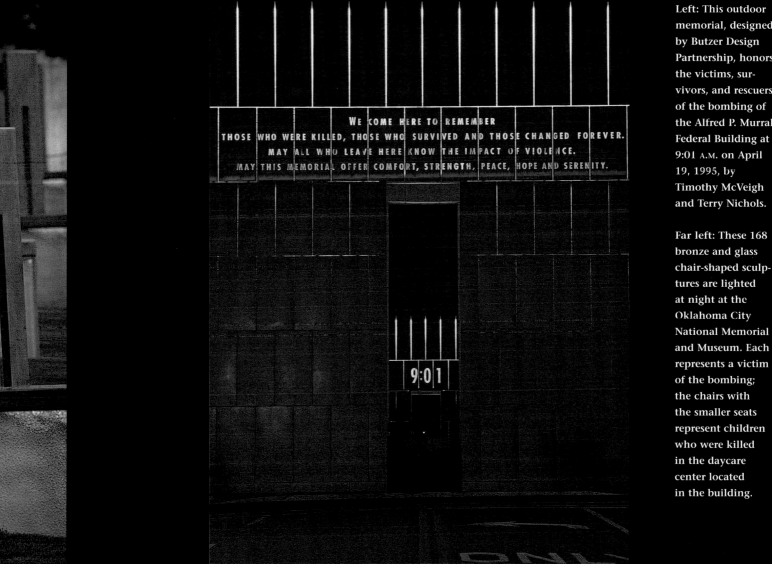

Left: This outdoor memorial, designed by Butzer Design Partnership, honors the victims, survivors, and rescuers of the bombing of the Alfred P. Murrah Federal Building at 9:01 A.M. on April 19, 1995, by Timothy McVeigh and Terry Nichols.

Far left: These 168 bronze and glass chair-shaped sculptures are lighted at night at the Oklahoma City National Memorial and Museum. Each represents a victim of the bombing; the chairs with the smaller seats represent children who were killed in the daycare center located in the building.

Right: The Golden Driller, as this 43,500-pound, seventy-six-foot-tall statue is known, was built in 1953 and first installed in front of the International Petroleum Exhibition Building at the Tulsa fairgrounds in 1966.

Far right: An Amish boy drives a hay wagon near Clarita in southeastern Oklahoma, an area known for its Amish families.

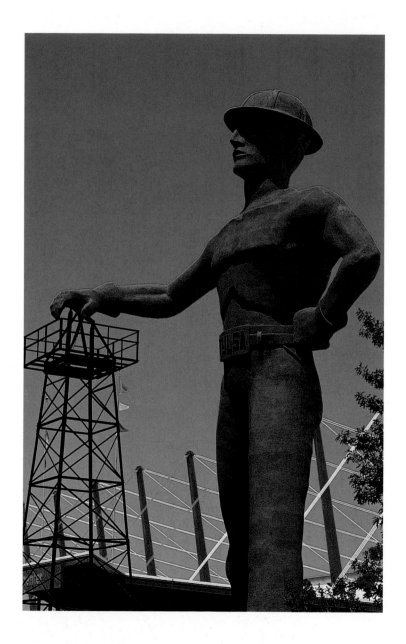

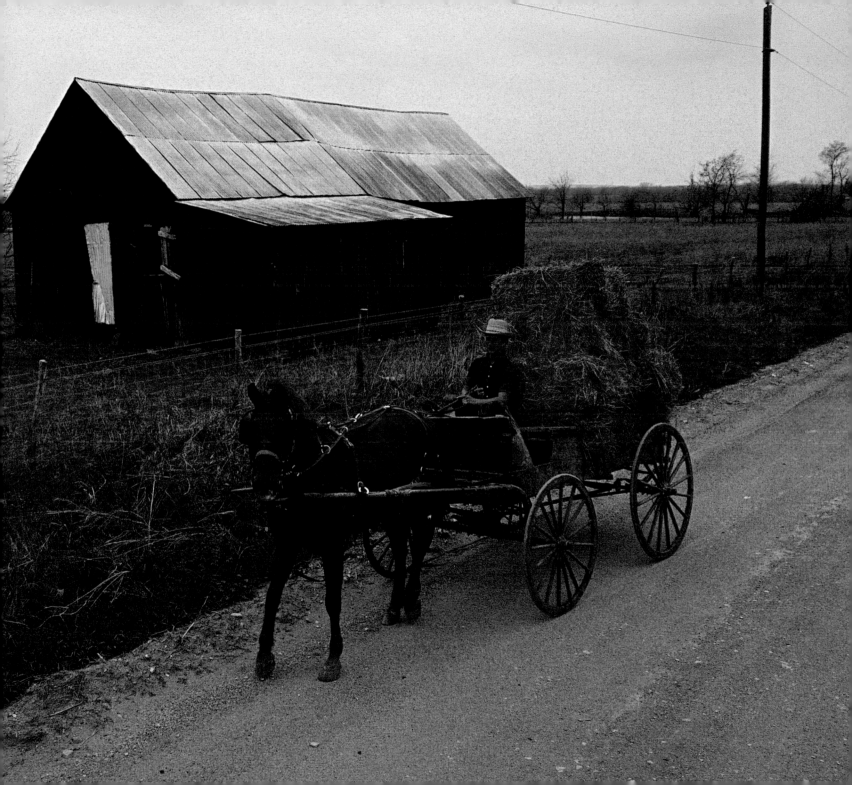

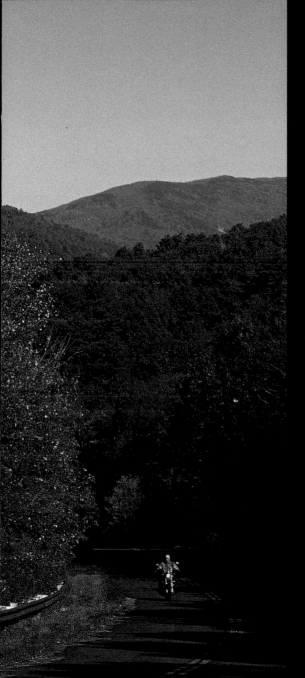

Left: Autumn intensifies the colors of Talimena Skyline Drive in Ouachita National Forest, the South's oldest national forest, created in 1907 by President Theodore Roosevelt.

Below: Indian blanketflower, which blooms in June and July, is Oklahoma's state wildflower and symbolizes the state's beauty and Indian heritage.

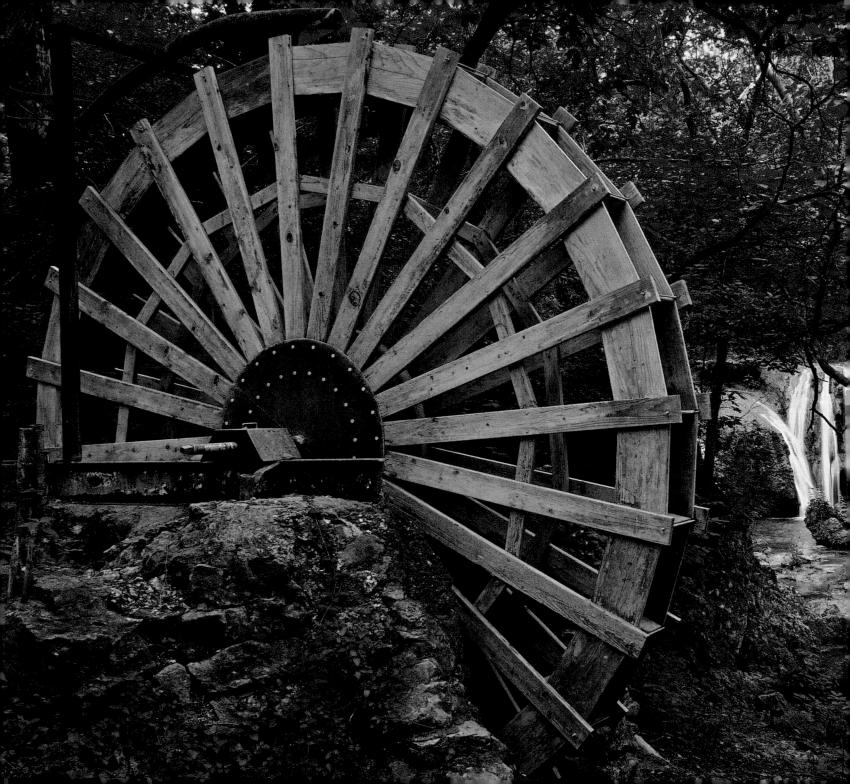

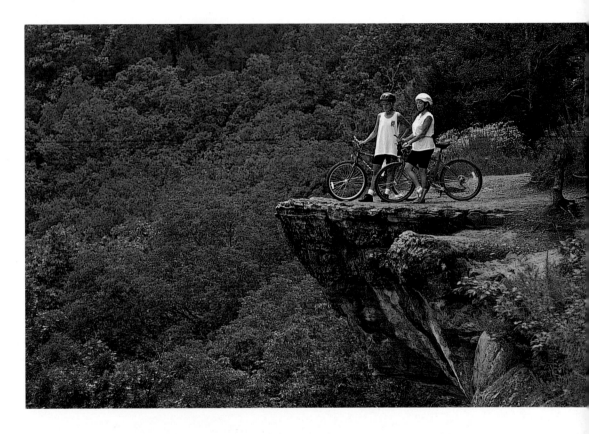

Above: Two cyclists pause on Goats Bluff, high above the 100-mile-long Illinois River, which forms Lake Tenkiller in eastern Oklahoma.

Left: This new waterwheel is located below Price Falls in the dense forest of the Arbuckle Mountains in southern Oklahoma.

Right: Early morning light warms the bluffs overlooking the Cimarron River in 200-acre Alabaster Caverns State Park.

Below: Blacks and bays, dapples and grays: a herd of wild mustangs grazes on the tallgrass prairie in Osage County.

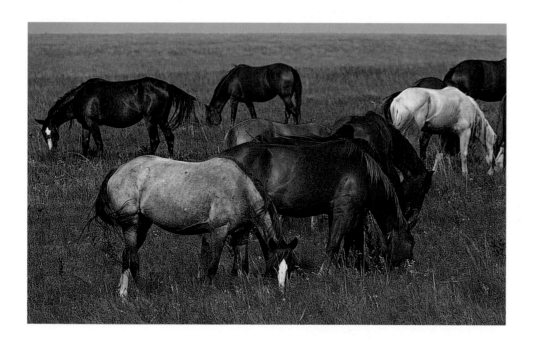

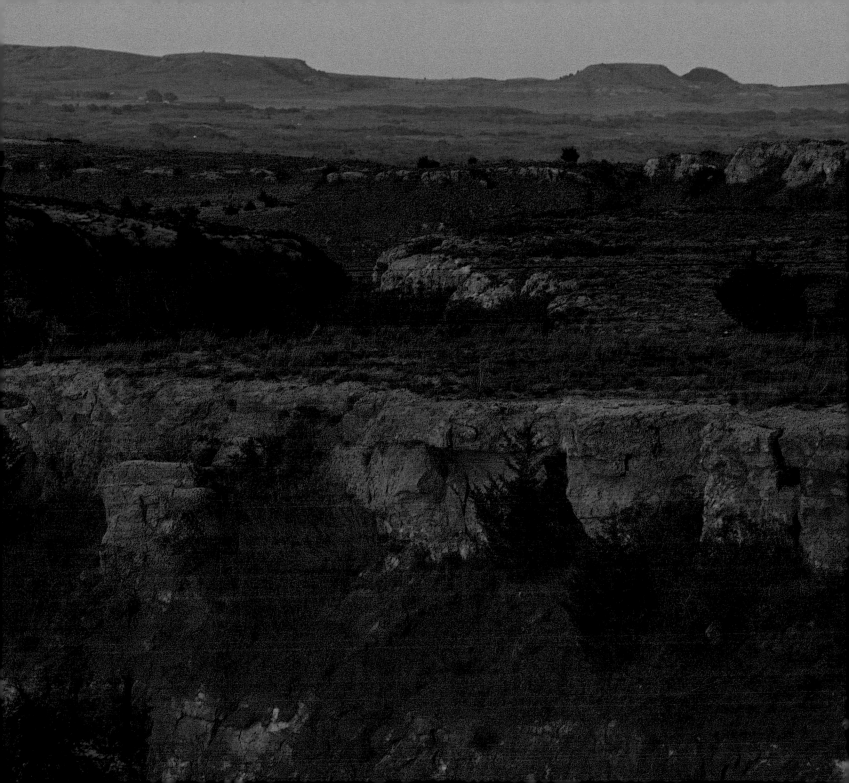

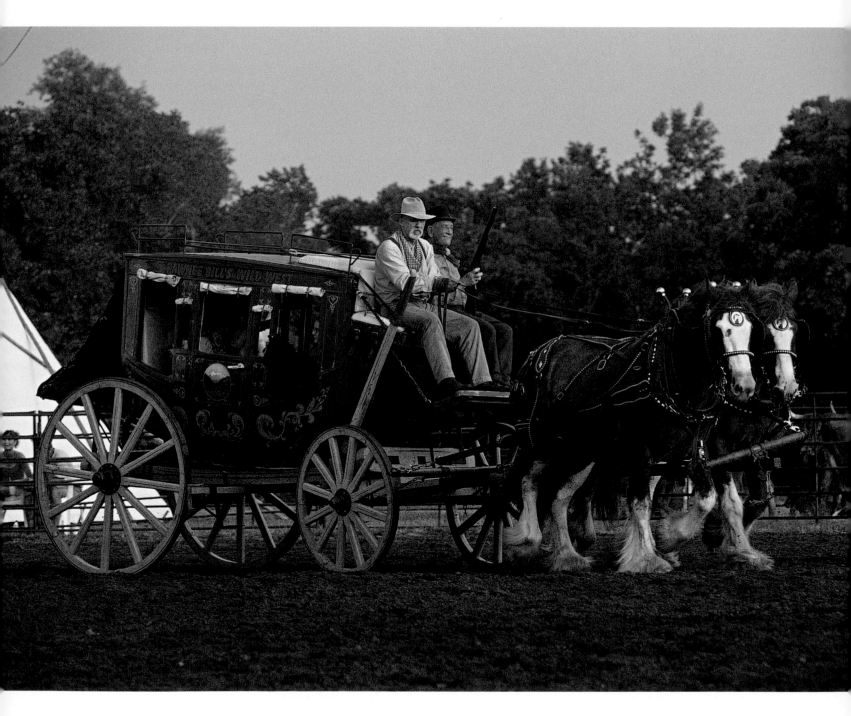

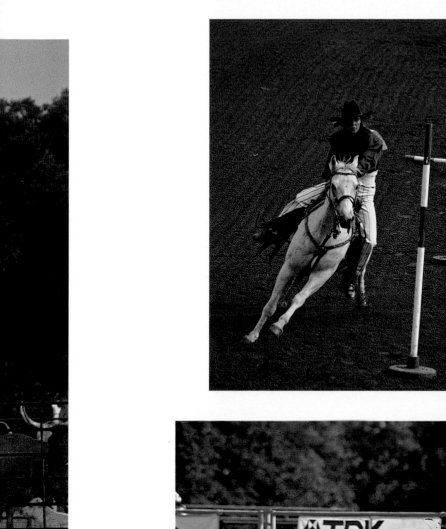

Left: This competitor guides her horse around the pole during the pole-bending event at the International Finals Youth Rodeo in July in the Heart of Oklahoma Exposition Center in Shawnee.

Far left: These performers and draft horses lead a stagecoach around the track during Pawnee Bill's Wild West Show in Pawnee, a re-enactment of the same-named show of ninety years ago featuring trick roping, trick riding, and cowboy songs.

Below: This young bull rider hangs on tightly during the International Finals Youth Rodeo. Other events include barrel racing, bronc riding, and calf roping.

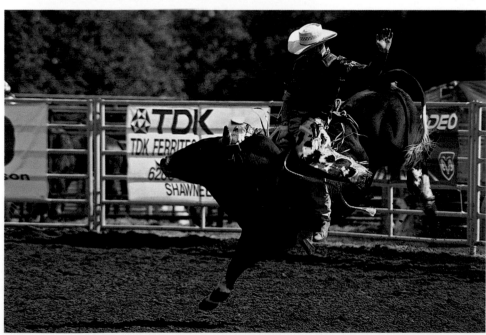

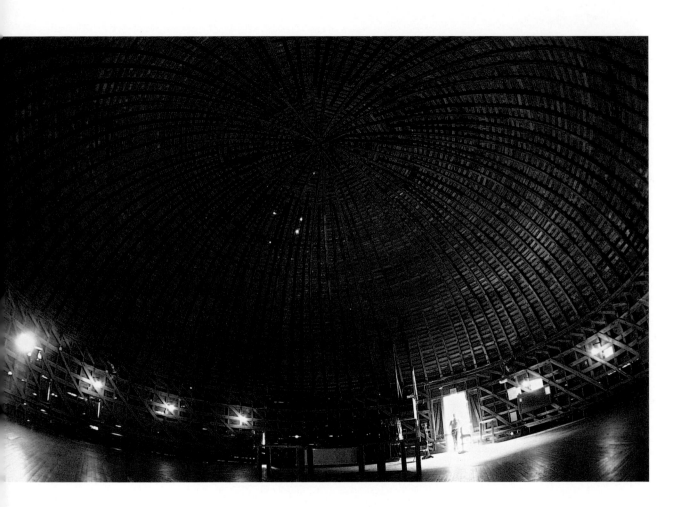

Above: The architecturally impressive ceiling of the two-story Round Barn in Arcadia. The original builders in 1898 believed that a round barn could withstand Oklahoma's tornadoes.

Right: A statue entitled *Welcome Sundown,* by artist Hollis Williford, stands in front of the National Cowboy and Western Heritage Museum in Oklahoma City.

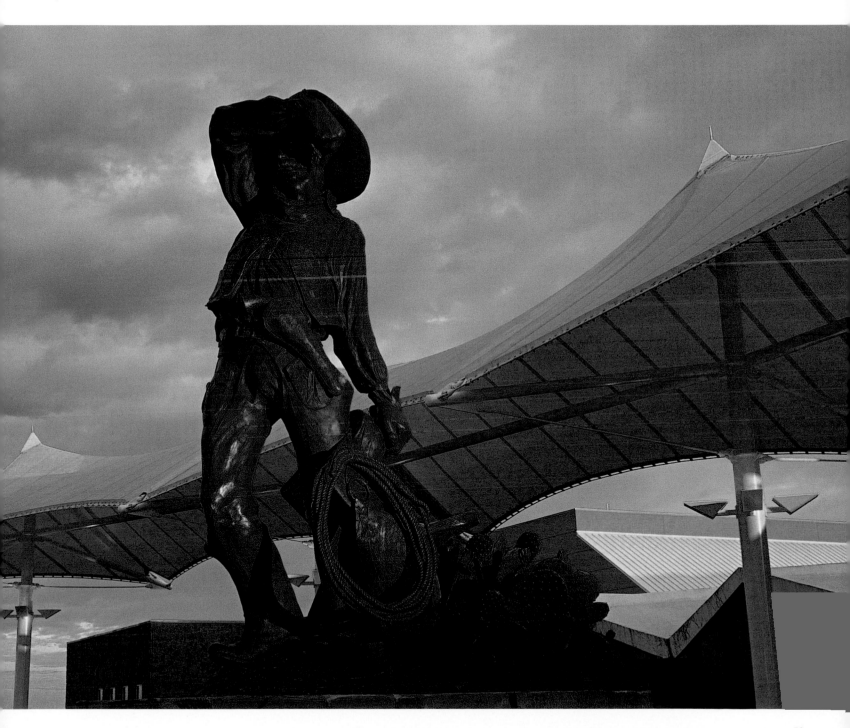

Left: The gypsum flakes in the red mesas at Gloss Mountain State Park in northwestern Oklahoma, also known as Glass Mountain, sparkle at dawn and at dusk.

Below: The ancient Viking hieroglyphics on the Heavener Runestone are the main attraction in the fifty-five-acre state park bearing the same name in southeastern Oklahoma.

Right: The sunset-edged sky is reflected in 13,000-acre Lake Tenkiller, which is surrounded by dogwood forests in the foothills of the Ozark Mountains.

Below: Fall fires the foliage of the oak trees around Lake Okmulgee, the center of 1,075-acre Lake Okmulgee State Park in eastern Oklahoma.

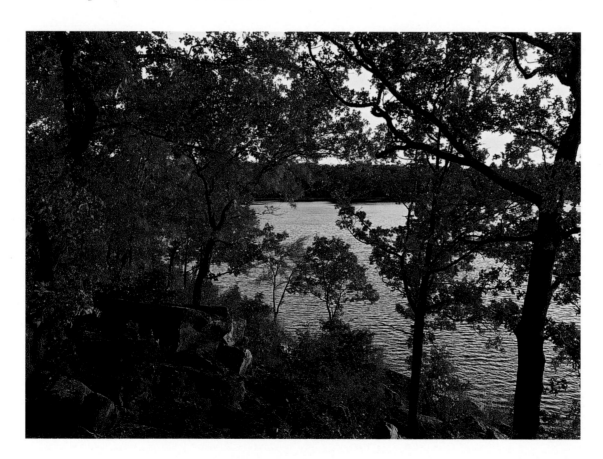

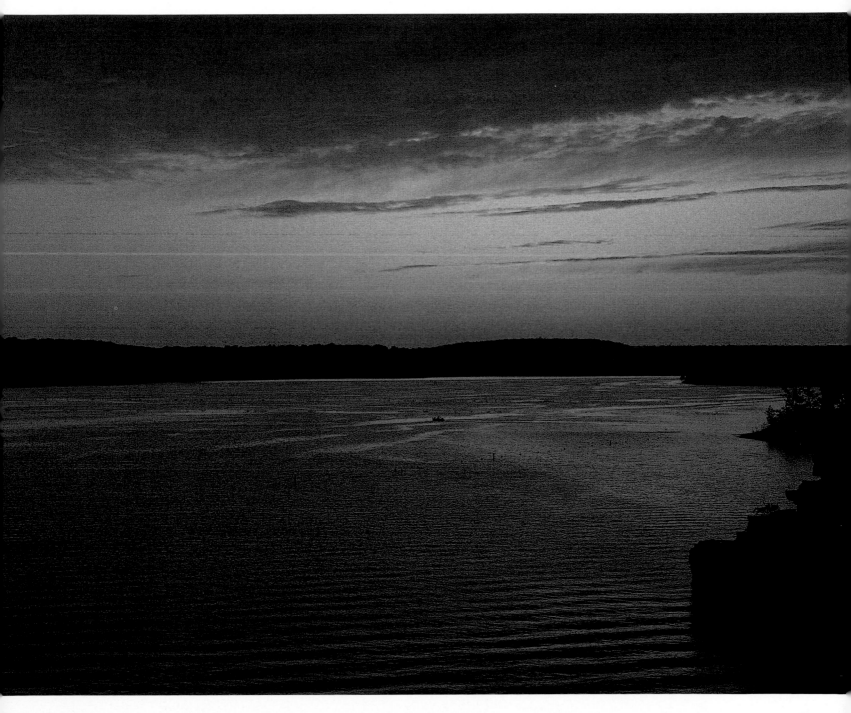

Right: Deep pink and red azaleas are just some of the 600 varieties that attract thousands of onlookers during the annual Muskogee Azalea Festival in April.

Below: This flowering dogwood tree, bordered by rows of tulips, is one of sixty varieties of dogwoods in Art Johnson Memorial Dogwood Collection in Muskogee's Honor Heights Park.

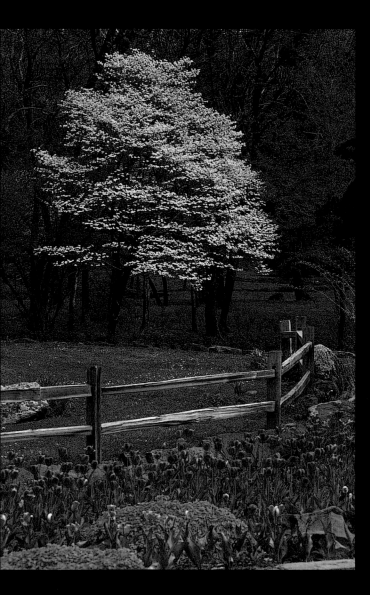

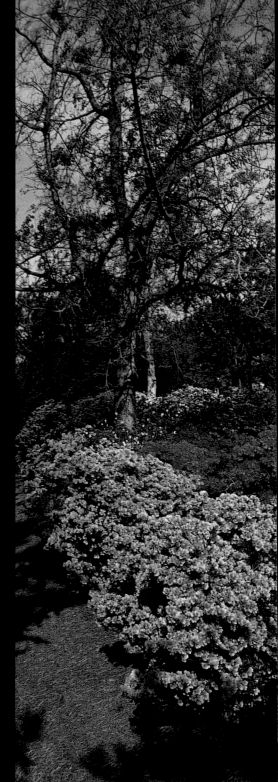

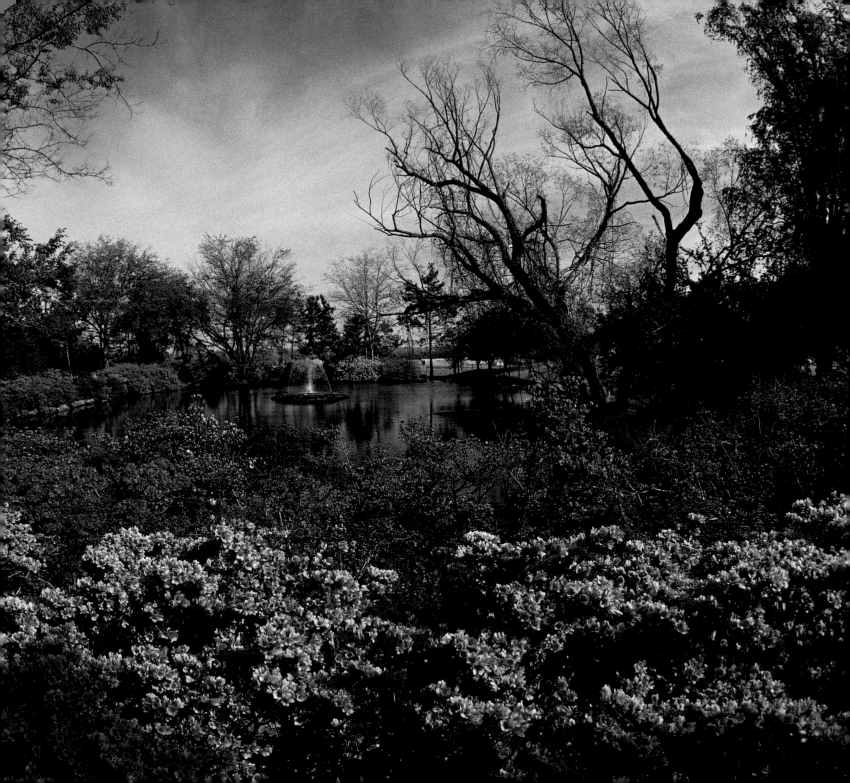

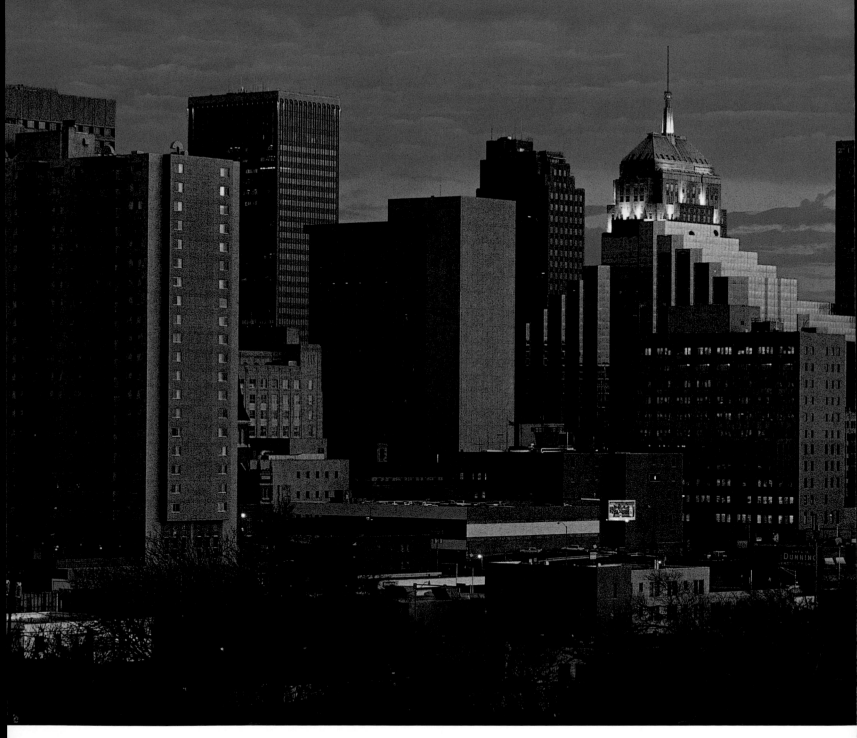

Left: The downtown Oklahoma City skyline glistens against the purple evening sky.

Below: A park naturalist enters Alabaster Caverns, the fifty-degree caves where visitors can see colorful selenite formations and five different species of bats.

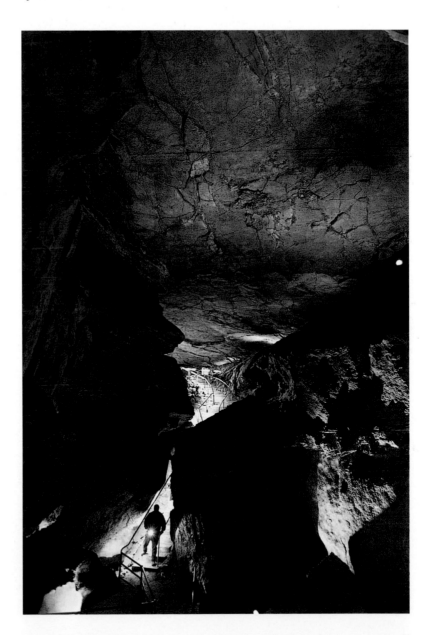

Right: Pistol Pete, the mascot of the Oklahoma State University Cowboys in Stillwater, is based on the real-life cowboy Frank "Pistol Pete" Eaton.

Far right: Fans pack the 84,000-seat Gaylord Family-Oklahoma Memorial Stadium in Norman to watch University of Oklahoma Sooners football games.

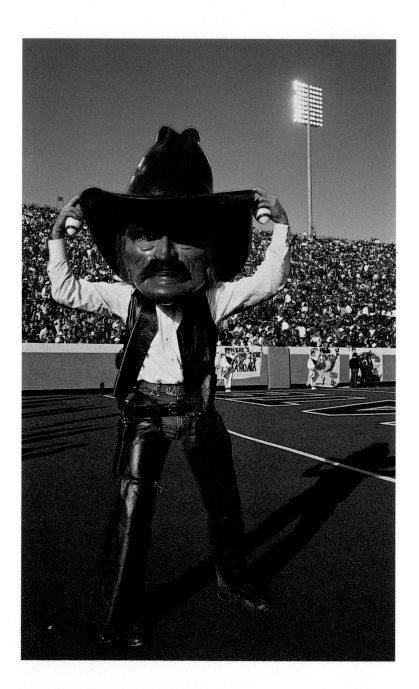

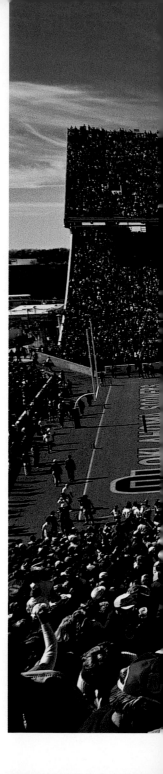

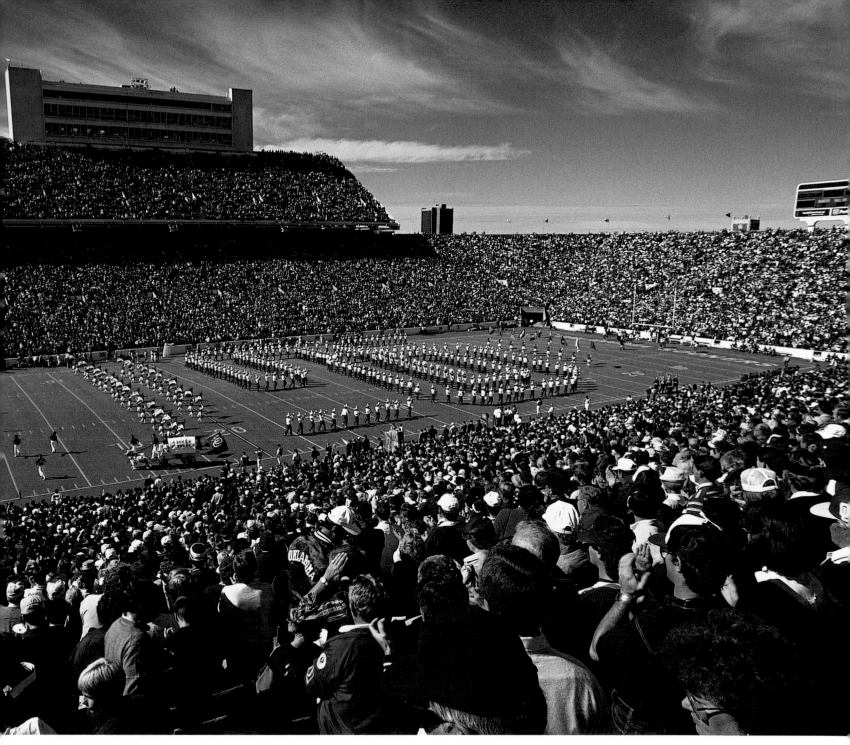

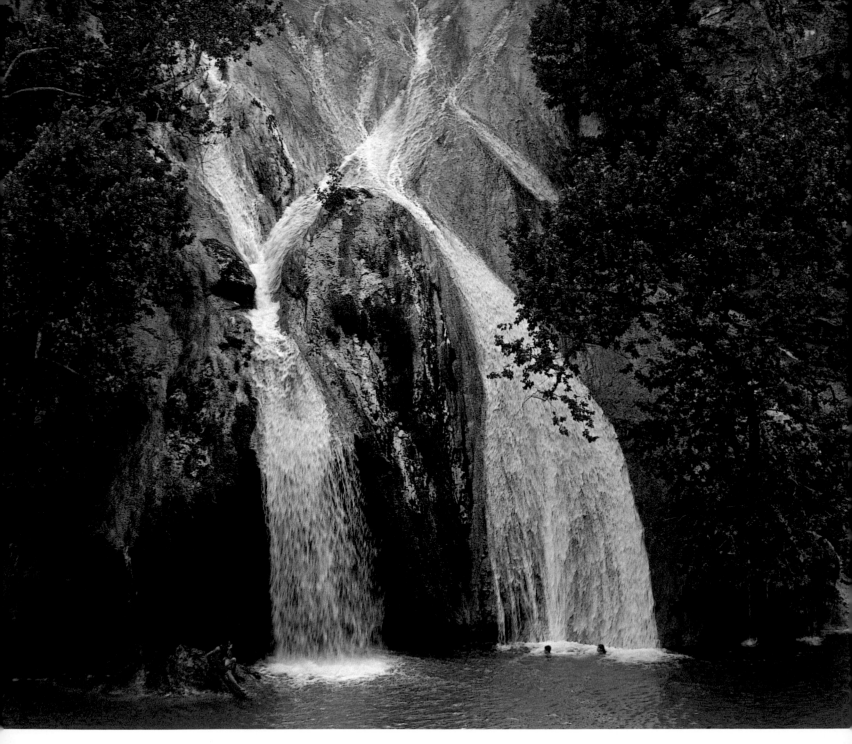

Left: A bather suns on a rock at the base of the spot where Honey Creek plunges over the hillside to form seventy-seven-foot-high Turner Falls, the largest waterfall in Oklahoma.

Below: The Crystal Bridge Tropical Conservatory at the Myriad Botanical Garden in Oklahoma City features nearly 1,000 plant species in two distinct areas that simulate a wet tropical forest and a dry tropical habitat.

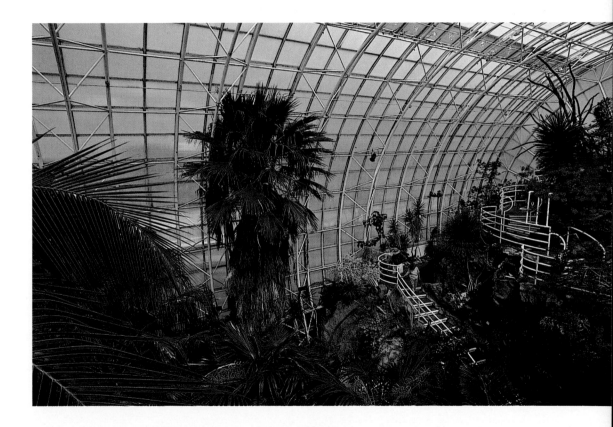

Right: These Victorian buildings are part of the national historic district in Guthrie, the town that served as the territorial and first state capital of Oklahoma.

Far right: Tourists enjoy a leisurely cruise down the Bricktown Canal, which flows through Oklahoma City's largest entertainment district.

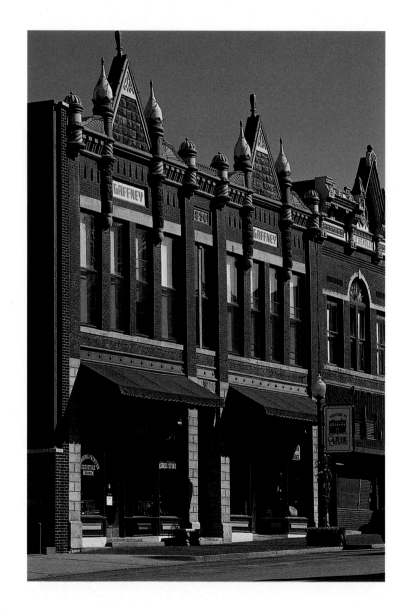

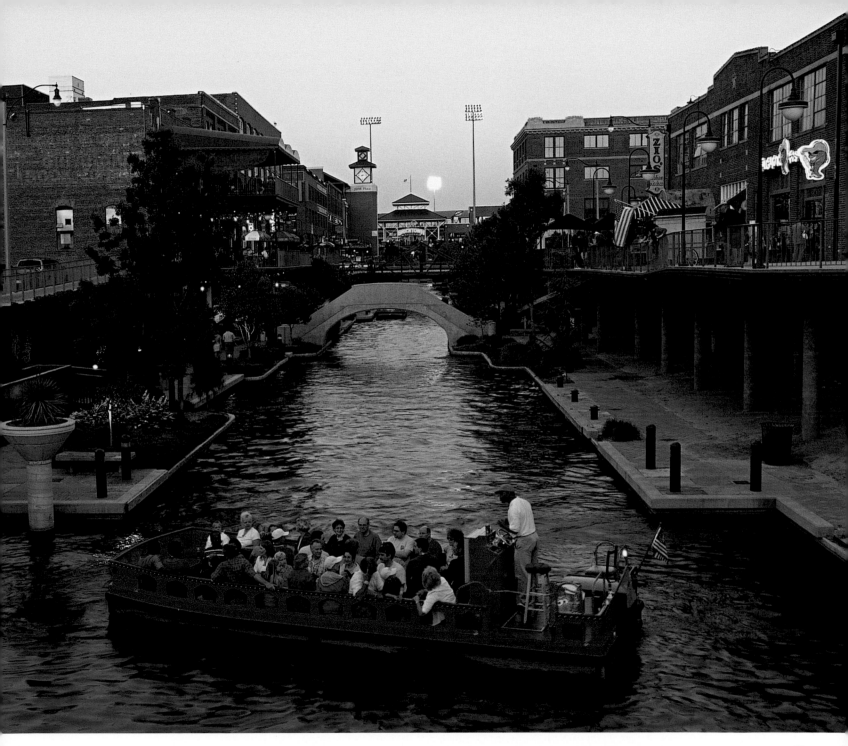

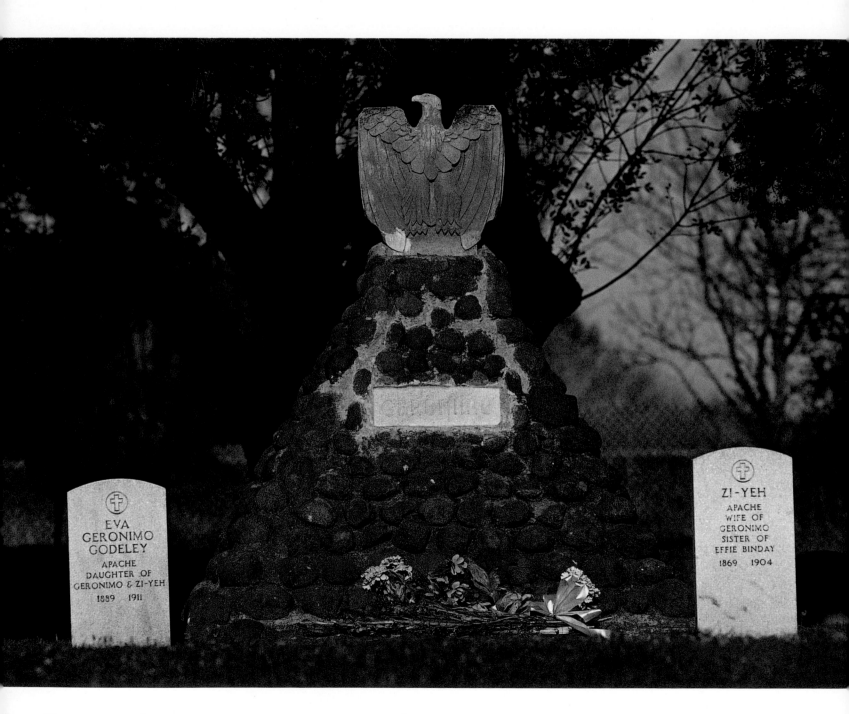

EVA
GERONIMO
GODELEY
APACHE
DAUGHTER OF
GERONIMO & ZI-YEH
1889 1911

ZI-YEH
APACHE
WIFE OF
GERONIMO
SISTER OF
EFFIE BINDAY
1869 1904

Facing page: Flowers lie at the gravesite of Geronimo, the prominent Apache leader who died in 1909 and was buried in the Apache Indian Prisoner of War Cemetery at Fort Sill in southwestern Oklahoma.

Below: Maintained by the Oklahoma Historical Society, the stone Fort Washita near Durant was built from 1841 to 1842 by General Zachary Taylor in the Choctaw Nation of Indian Territory and was used as a staging ground during the Mexican War.

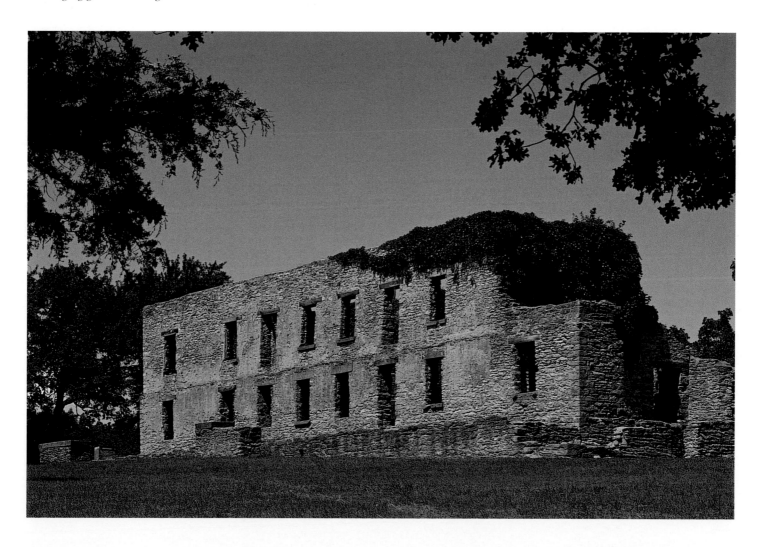

Right: This re-enactor in buckskin cloth-
ing is part of the annual Fort Washita
Fur Trade Rendezvous held each April
near Durant.

Far right: Asian dancers flutter their
bright fans as they perform at one of
several Asian festivals held throughout
the year in Oklahoma City, which has
the largest Asian population in the state.

Below: Musicians strum their banjos
during the parade for the Guthrie Jazz
Banjo Festival, featuring jazz musicians
and the world's largest banjo band.

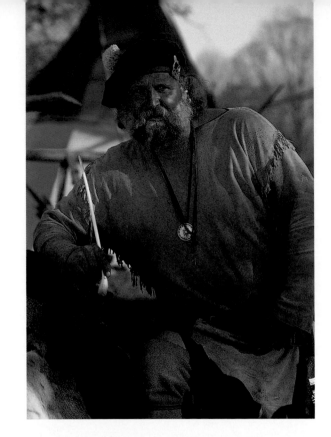

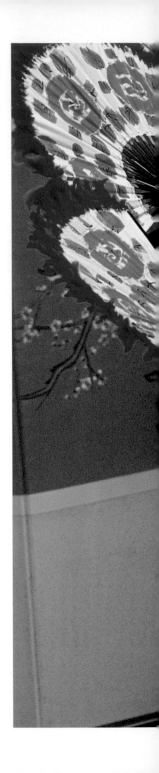

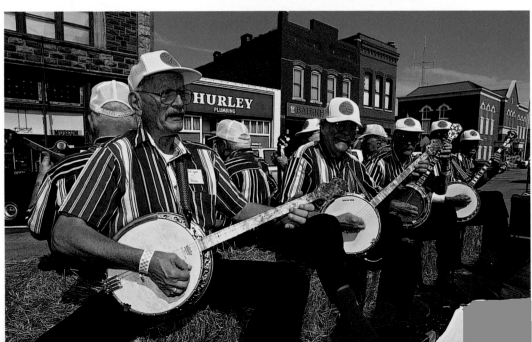

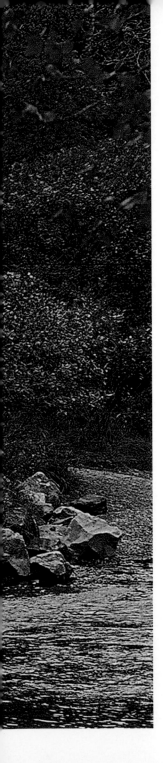

Left: Framed by a forest just beginning to turn color, a park visitor and her dog watch the waters of the Mountain Fork River in Beavers Bend State Resort Park, an area sometimes referred to as Oklahoma's "little Smokies."

Below: Two deer in Beavers Bend State Resort Park pause in their grazing, ears cocked, as they sense the presence of another animal.

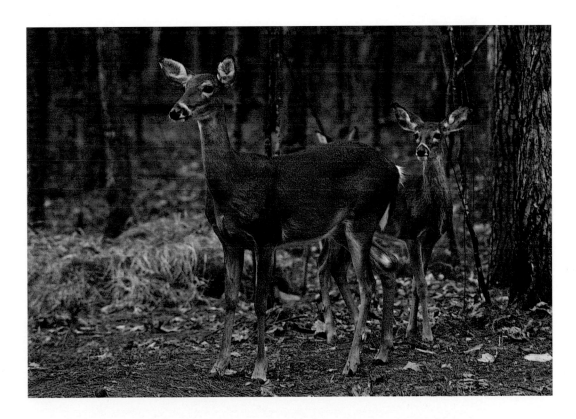

Right: Two anglers are silhouetted against the darkening Lake of the Arbuckles, a manmade lake located in the Chickasaw National Recreation Area.

Below: Oologah Lake, near Tulsa, was named for a Cherokee word that means "dark cloud" and is a popular spot with sailors.

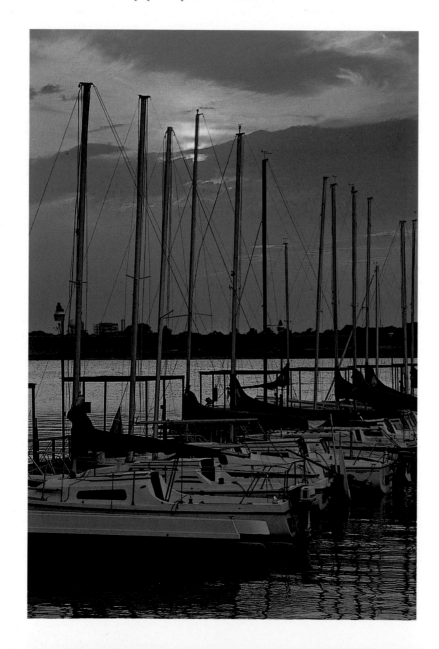

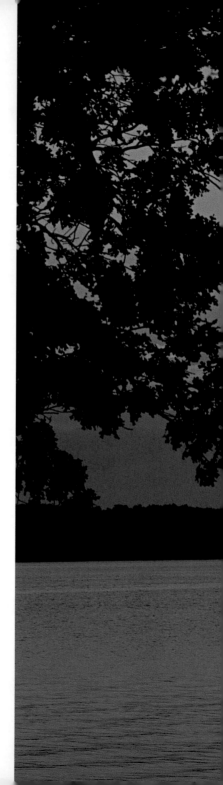

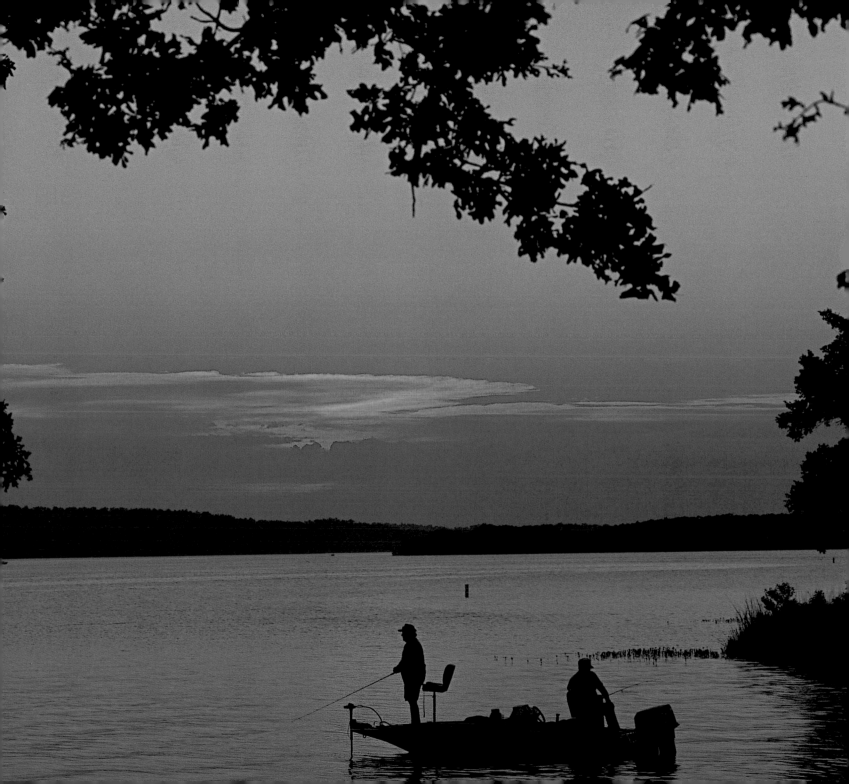

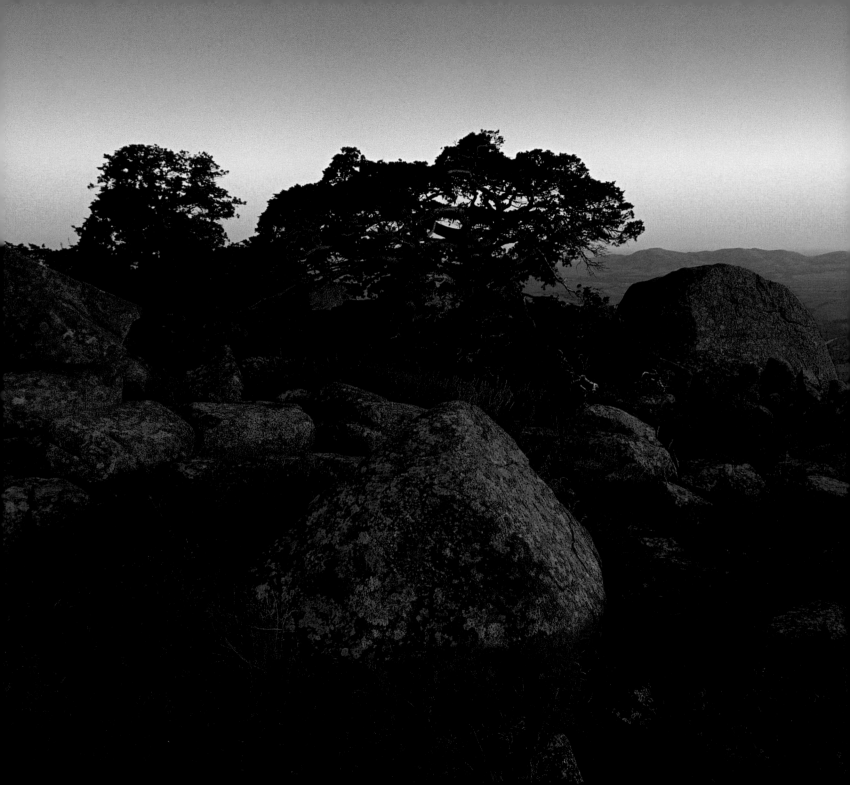

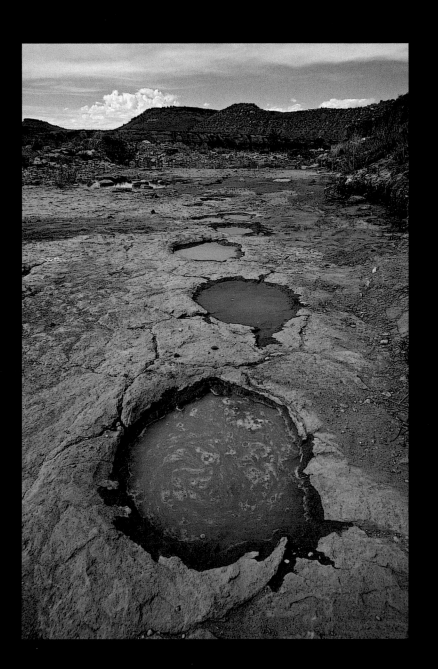

Left: Small steps for
a dinosaur, large steps
for mankind: these
fossilized tracks in
the Black Mesa region
of Cimarron County
date back as far as 140
million years ago.

Far left: Sunset reddens
the boulders on Mount
Scott, which overlooks
the Wichita Mountains,
an ancient range located
in southwestern
Oklahoma.

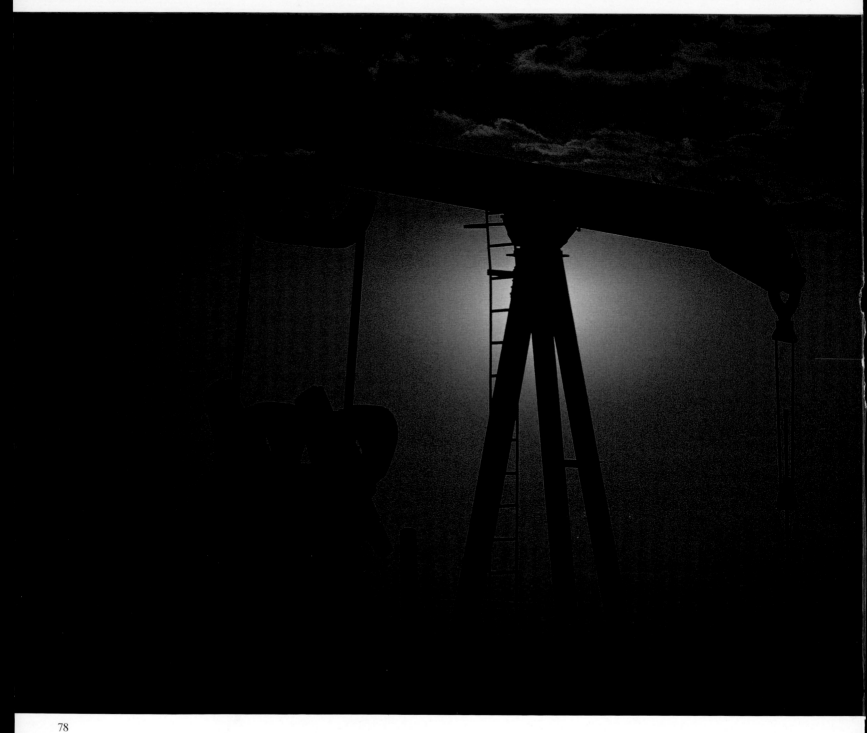

Left: This pump jack, silhouetted by a blazing sun, works day and night on the Tallgrass Prairie in Osage County.

Below: The sun sets on 17,000-acre Kaw Lake near Ponca City, a popular recreation spot that was created in 1976 when the Army Corps of Engineers dammed the Arkansas River.

JIM ARGO

Jim Argo began his photojournalism career while a student at Texas Tech University in Lubbock, Texas. He worked for two Texas newspapers before moving to Oklahoma City and the largest state newspaper, *The Daily Oklahoman,* and its sister publication, the *Oklahoma City Times,* in 1963. He soon developed a passion for photographing the Oklahoma landscape and its people, winning several local, national, and international awards for his photography and writing.

His freelance assignments have included major news magazines, including *Business Week, Newsweek, Time,* and *National Geographic,* as well as several smaller publications. Two of his photographs were reproduced as wall murals that hung in the National Gallery of Art in Washington, D.C., as part of the special exhibit commemorating the 100th birth year of famed artist Georgia O'Keeffe.

Argo was a contributing photographer to the book *Oklahoma Simply Beautiful* (Farcountry Press). He has co-authored three books published by the Oklahoma Historical Society and was a major photographic contributor to thirteen other books on the state. He was inducted into the Oklahoma Journalism Hall of Fame in 1997. Argo retired as the *The Oklahoman* photo editor in 2003. However, he continues to travel throughout Oklahoma photographing the landscape and its people.

Jim and his wife, Burnis, live in Edmond, a suburb of Oklahoma City, with his rambunctious beagle, Shannon, and two black cats, Styx and Missy.